SIMON &
SCHUSTER

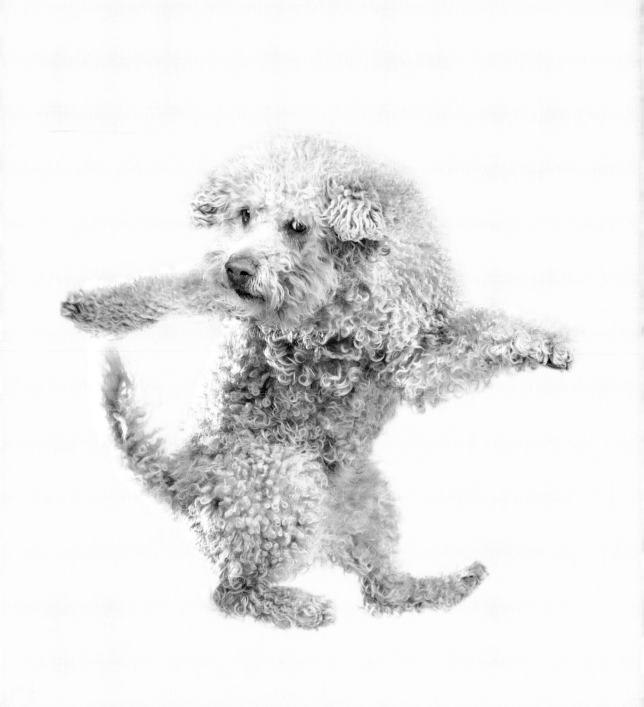

FLYING
DOGS

JULIA CHRISTE

**SIMON &
SCHUSTER**

London · New York · Sydney · Toronto · New Delhi

A CBS COMPANY

First published in Great Britain by Simon & Schuster UK Ltd, 2016
A CBS COMPANY

Copyright © 2016 by Julia Christe

This book is copyright under the Berne Convention.
No reproduction without permission.
All rights reserved.

The right of Julia Christe to be identified as the author of this work
has been asserted by her in accordance with sections 77 and
78 of the Copyright, Designs and Patents Act, 1988.

1 3 5 7 9 10 8 6 4 2

Simon & Schuster UK Ltd
1st Floor
222 Gray's Inn Road
London WC1X 8HB

www.simonandschuster.co.uk
www.simonandschuster.com.au
www.simonandschuster.co.in

Simon & Schuster Australia, Sydney
Simon & Schuster India, New Delhi

The author and publishers have made all reasonable efforts
to contact copyright-holders for permission, and apologise
for any omissions or errors in the form of credits given.
Corrections may be made to future printings.

A CIP catalogue record for this book
is available from the British Library

Hardback ISBN: 978-1-4711-6082-0
eBook ISBN: 978-1-4711-6083-7

Printed and bound in Slovenia by GPS

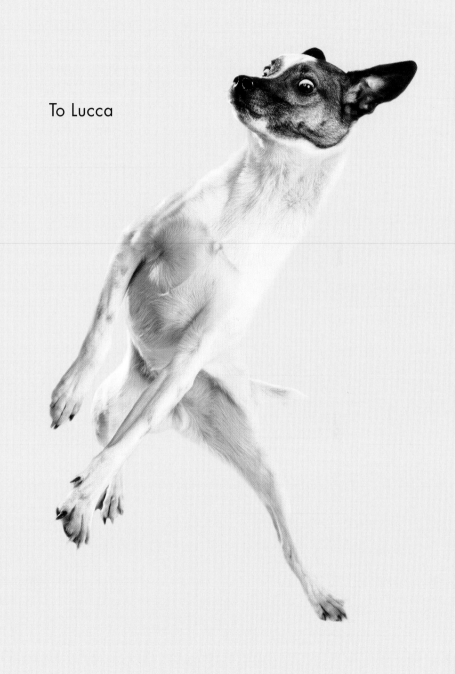

To Lucca

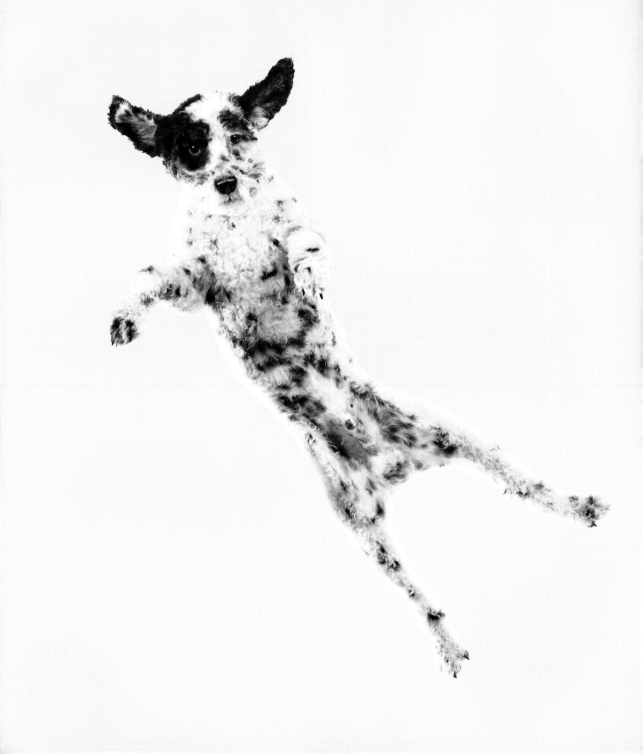

FLYING DOGS

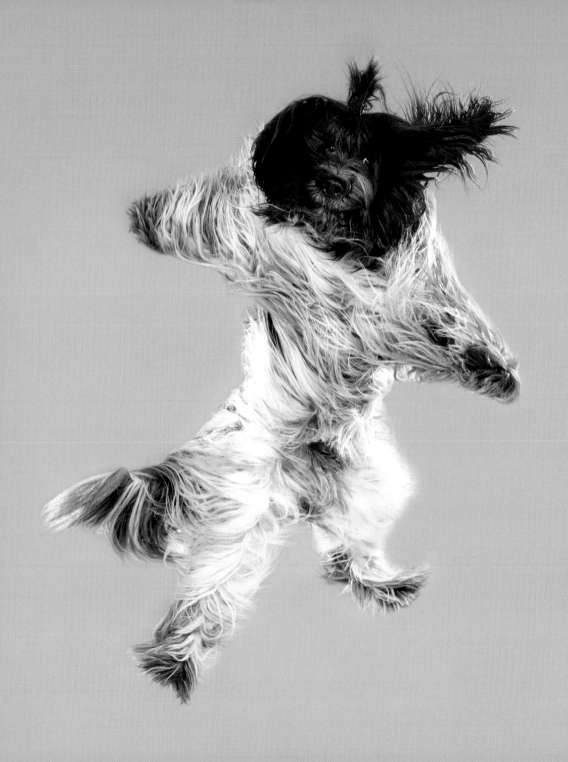

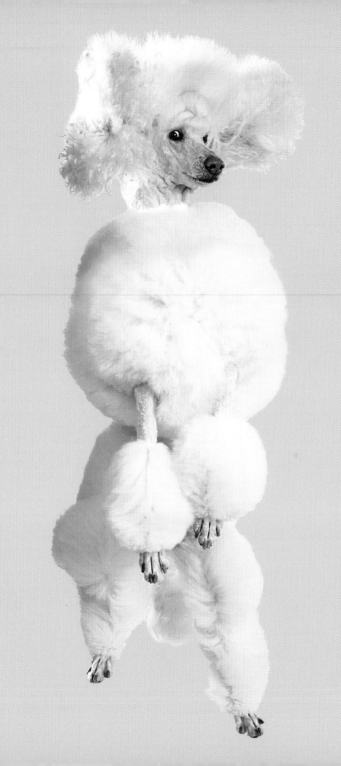

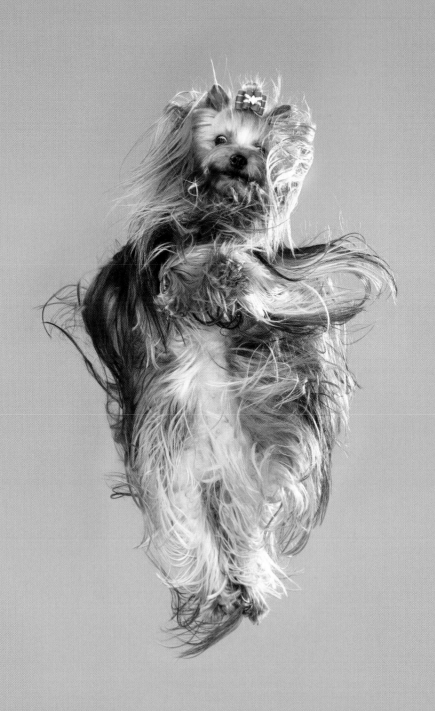

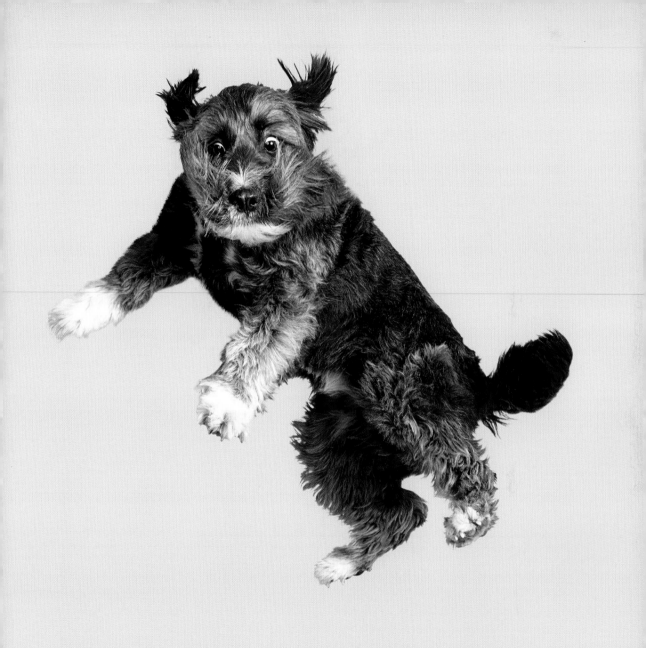

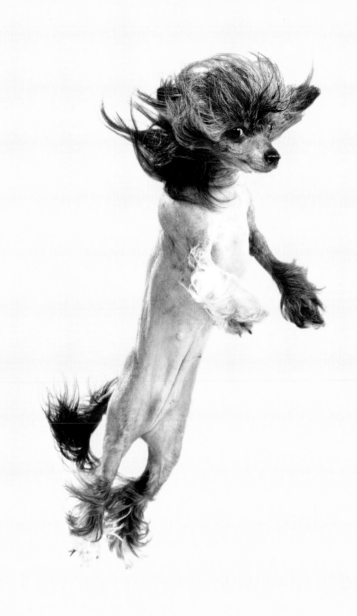

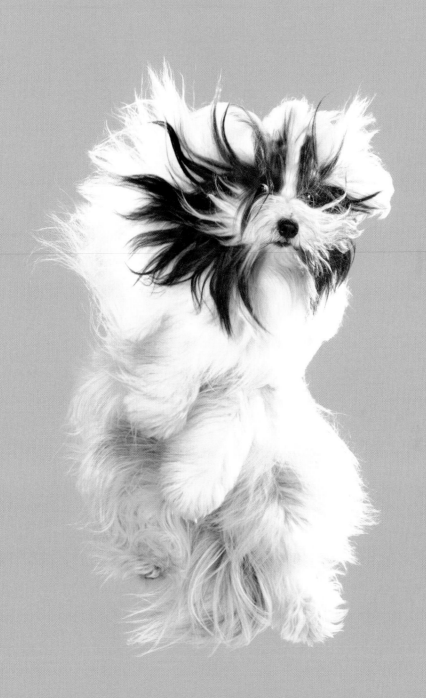

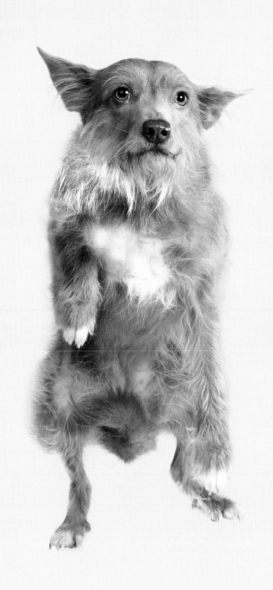

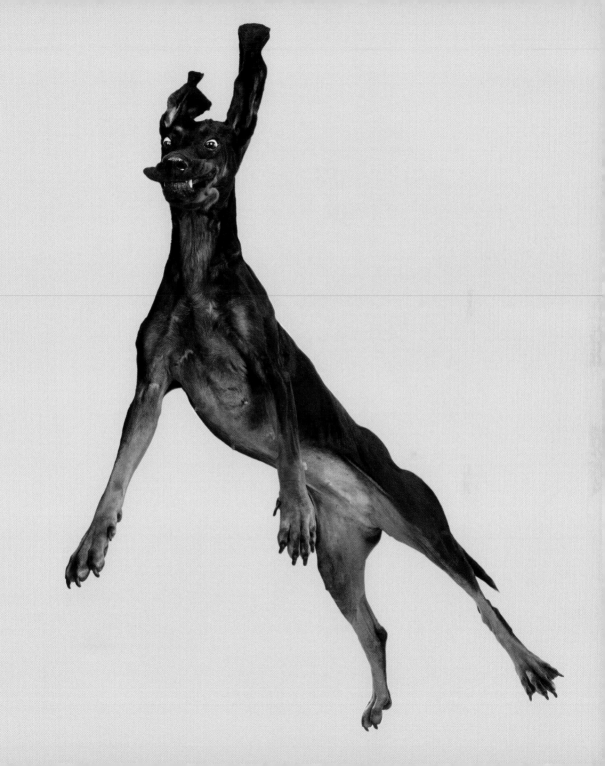

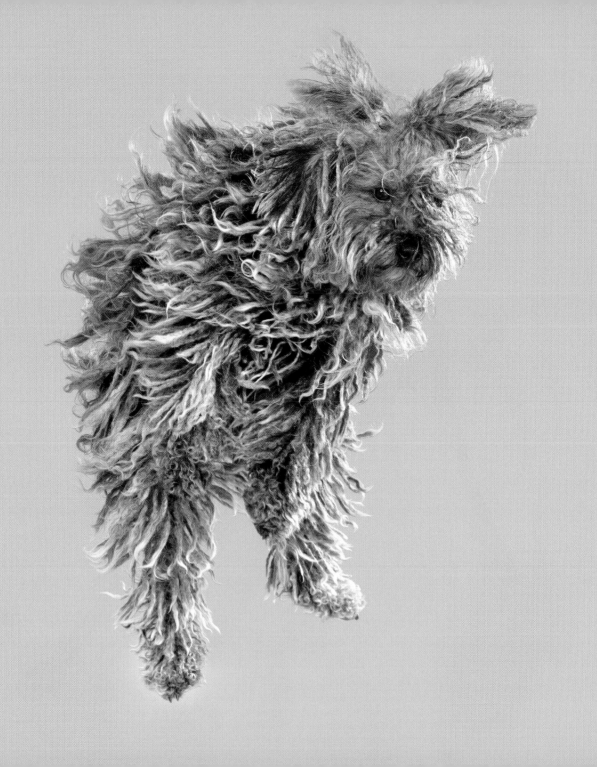

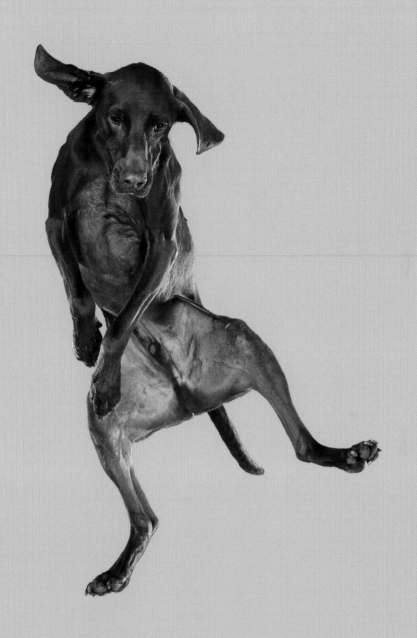

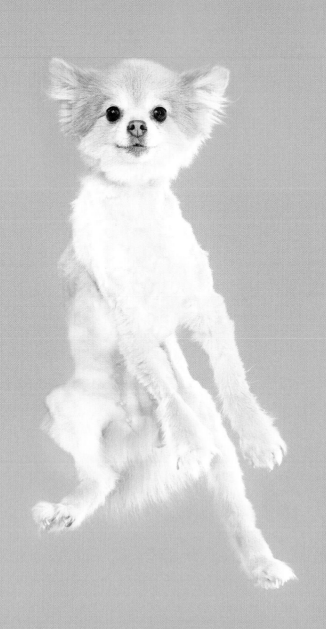

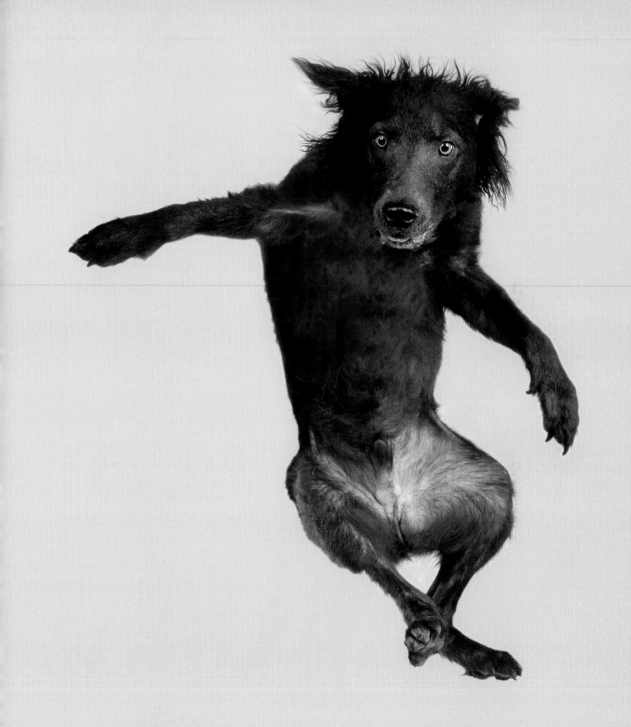

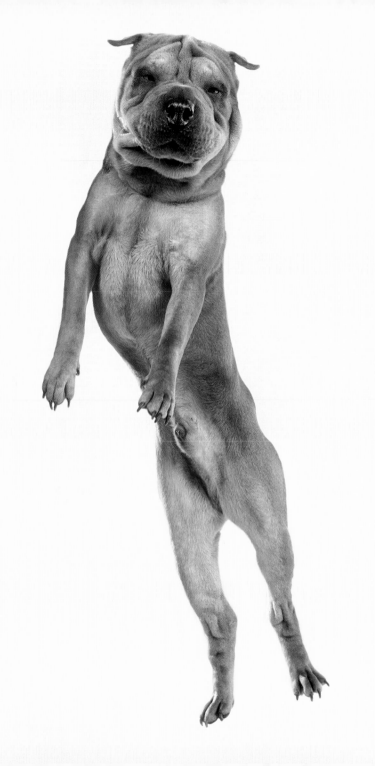

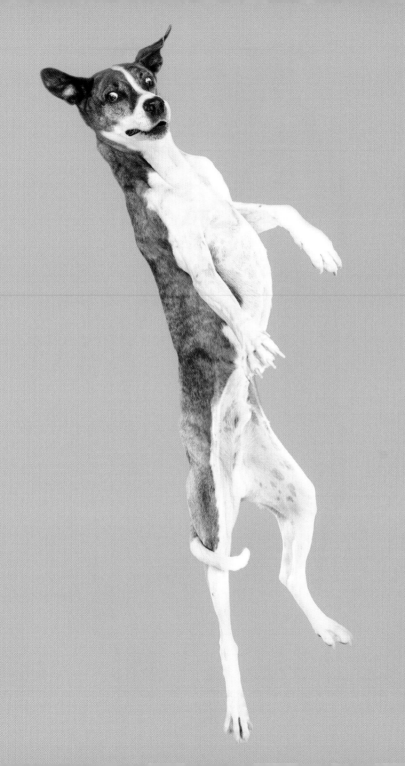

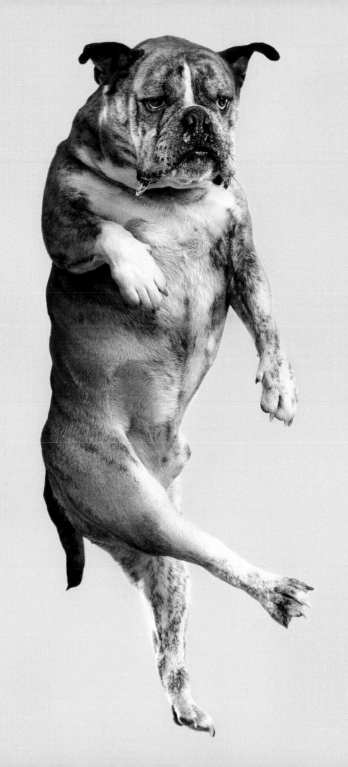

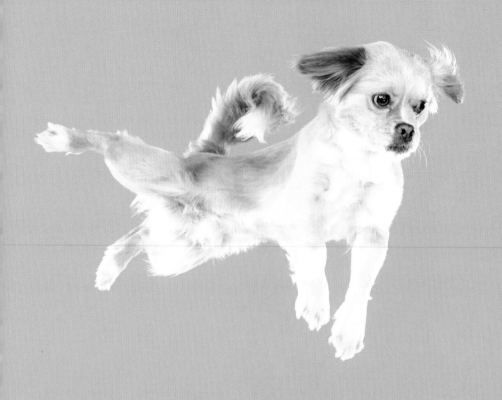

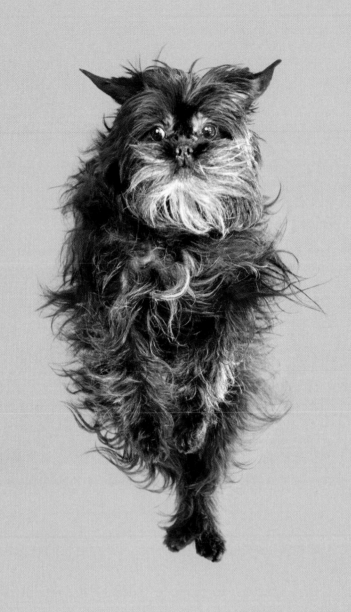

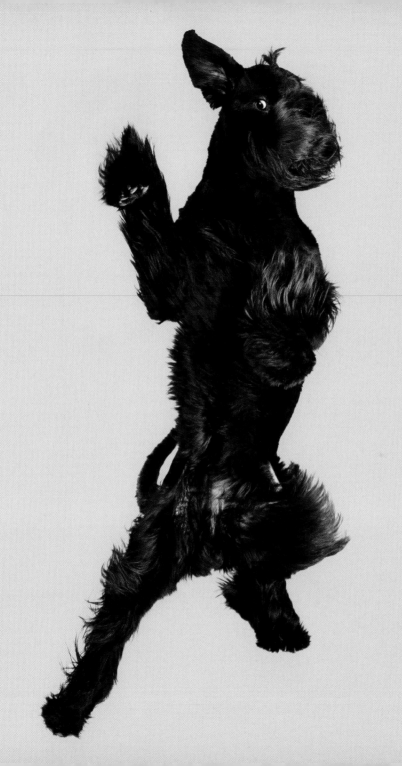

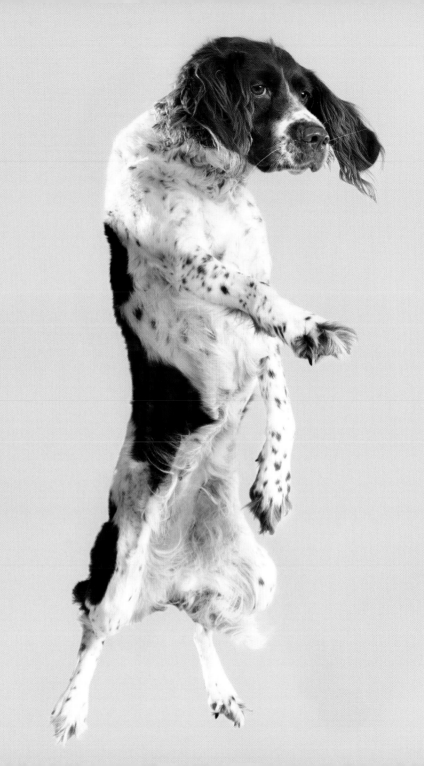

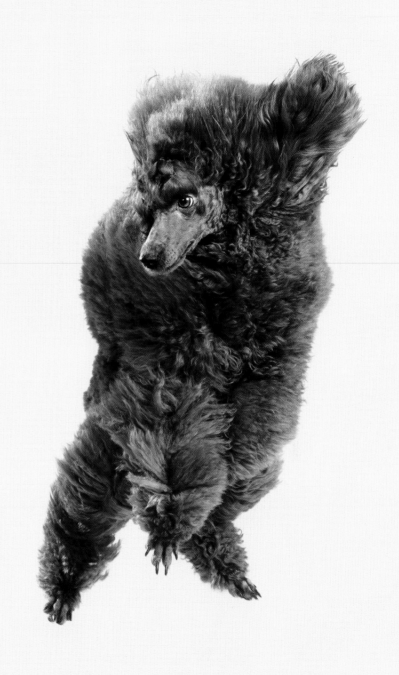

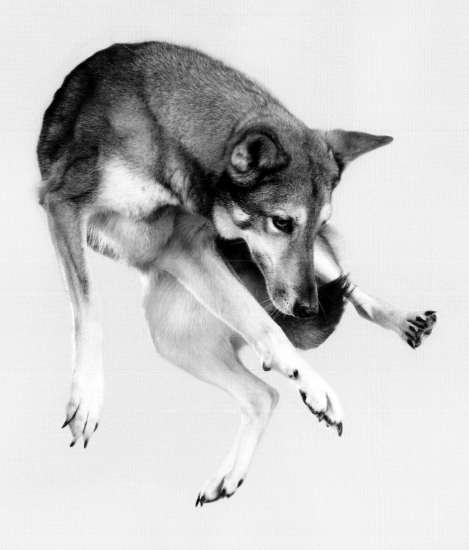

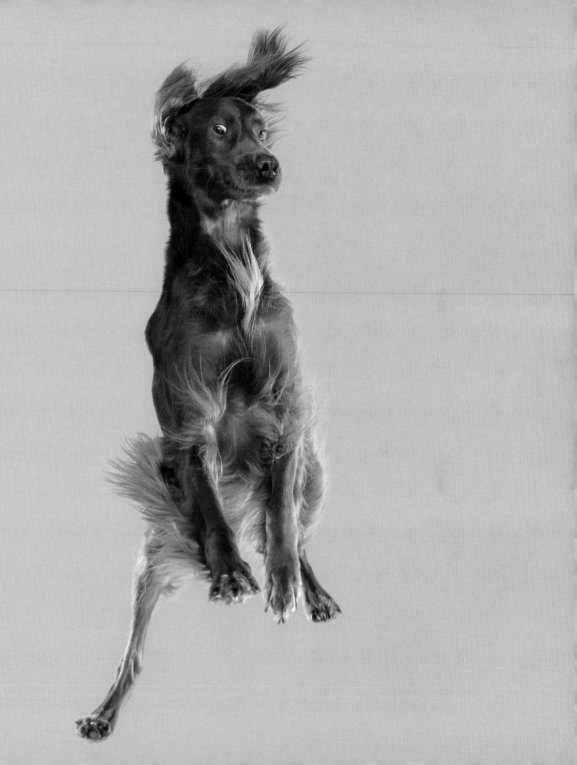

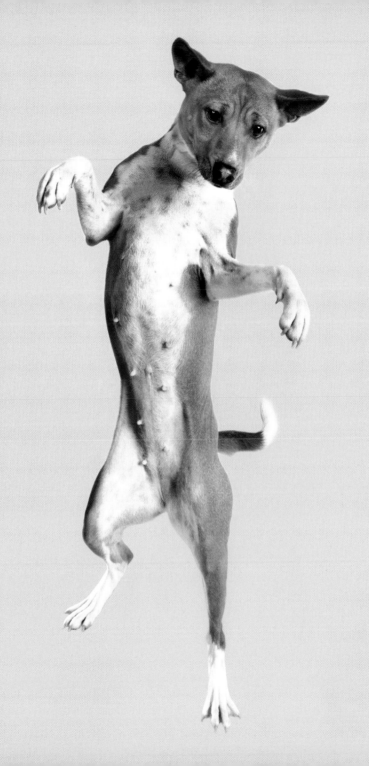

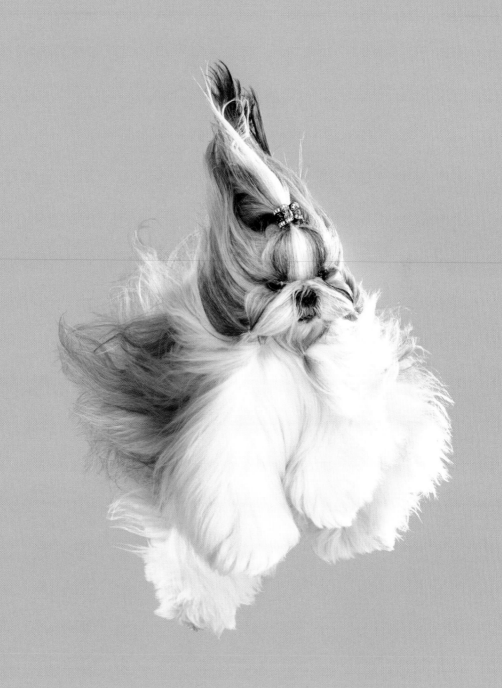

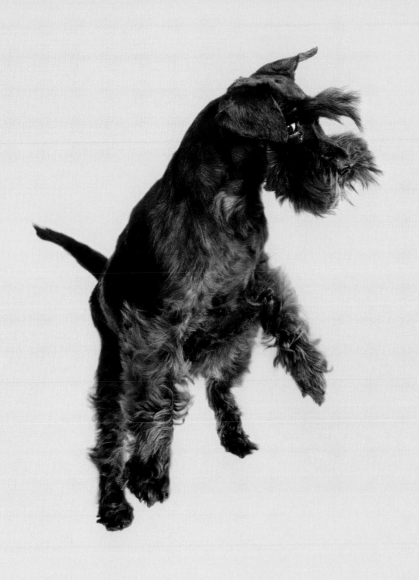

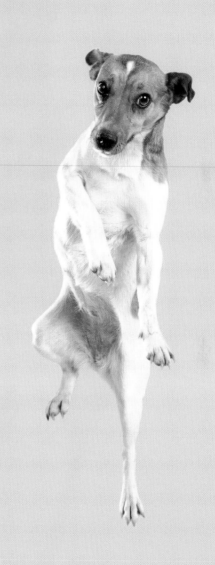

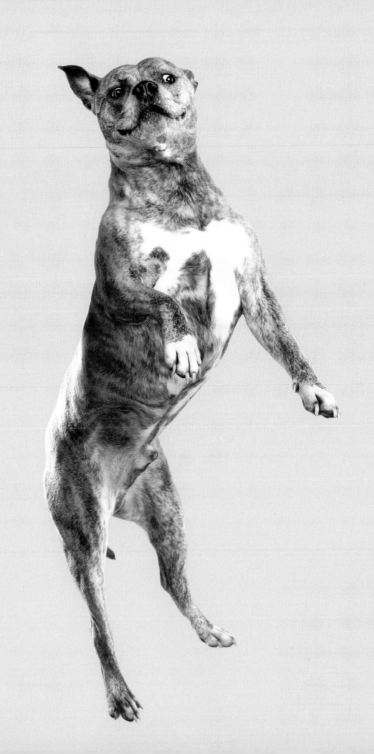

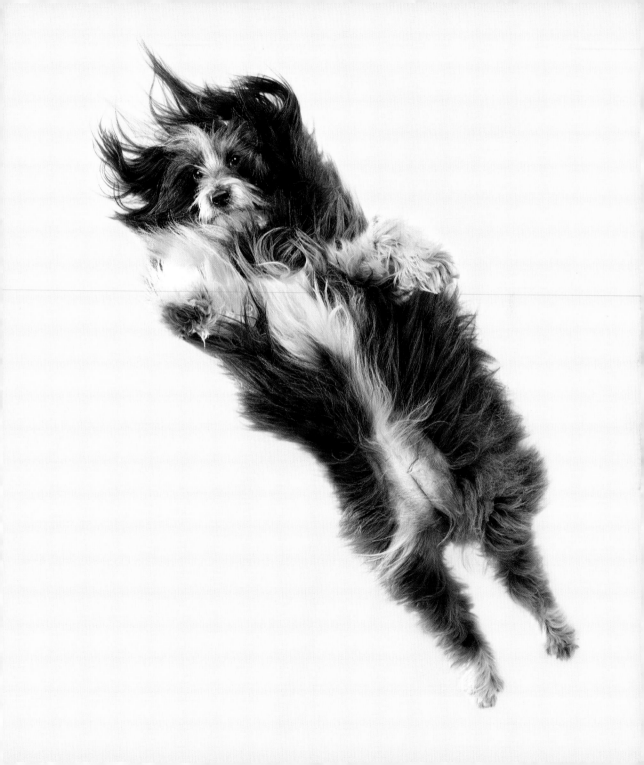

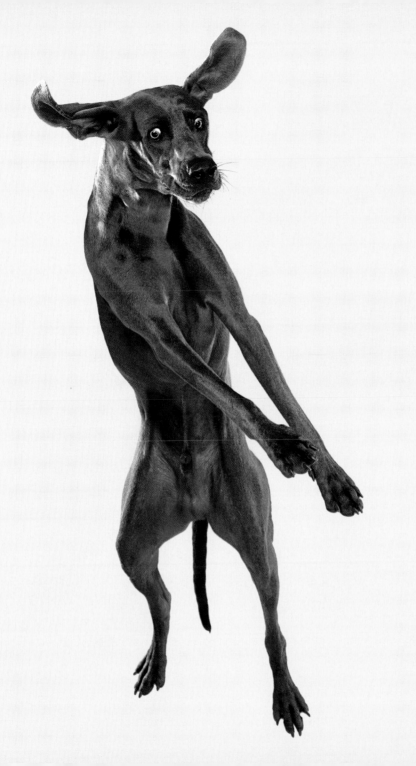

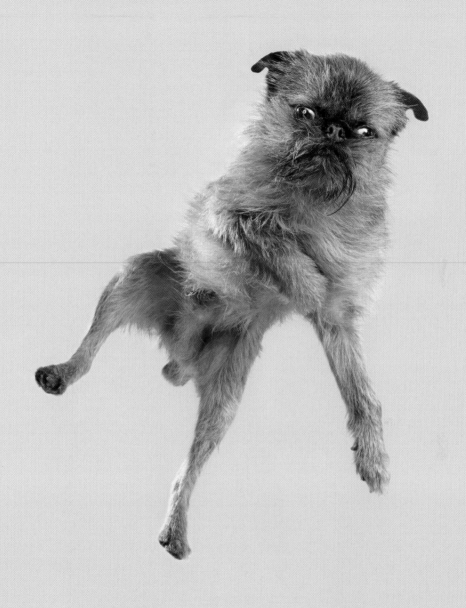

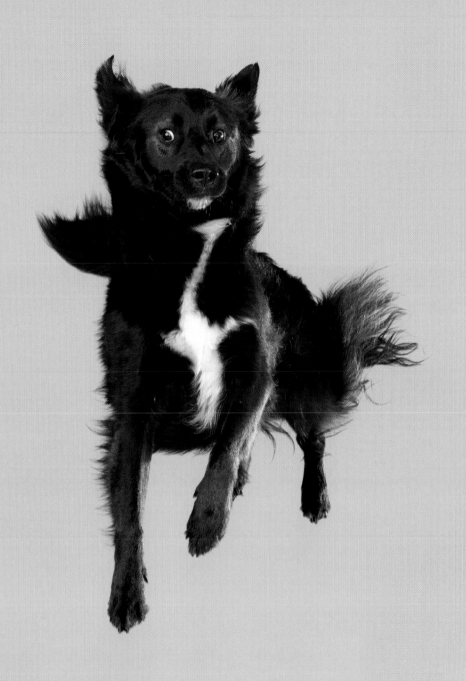

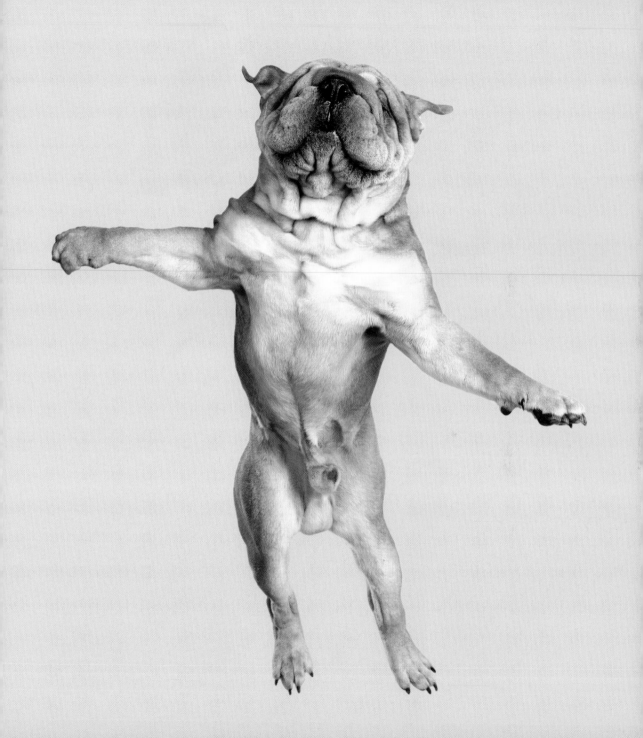

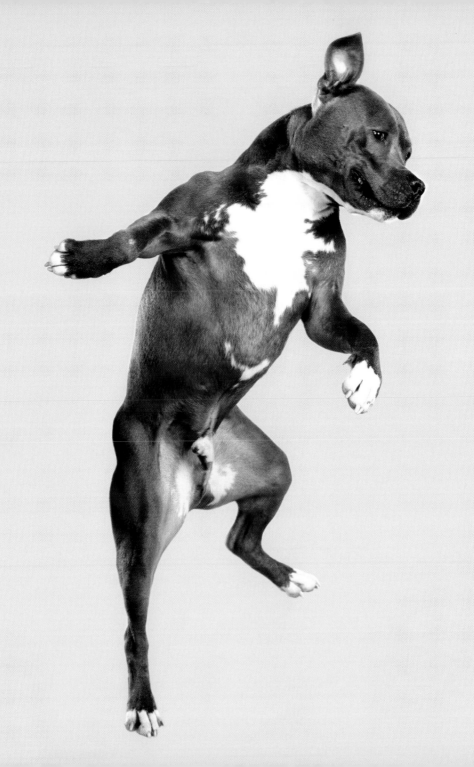

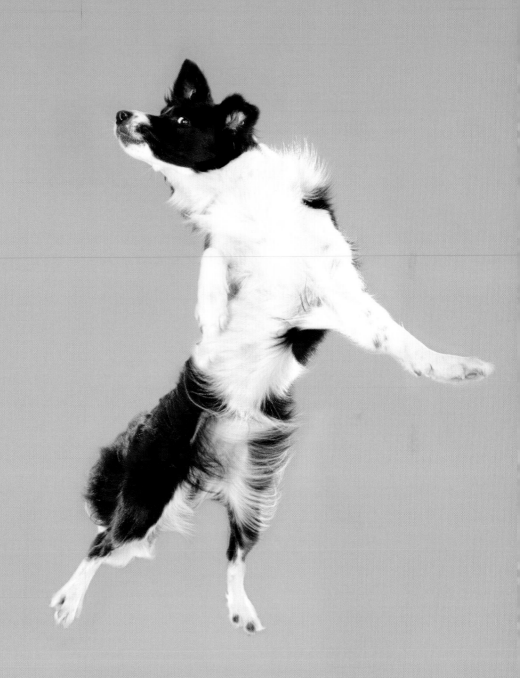

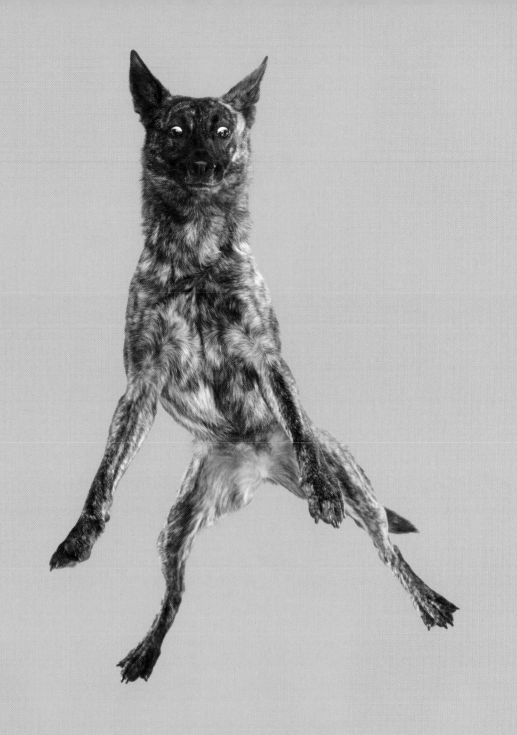

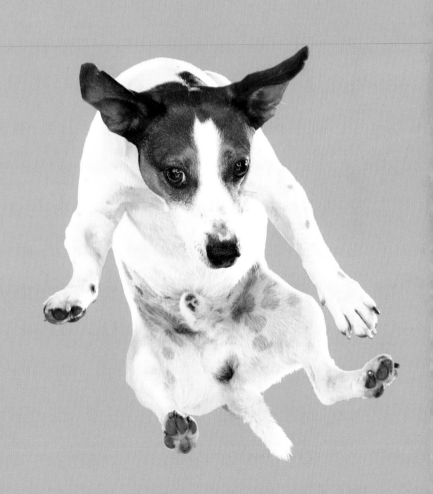

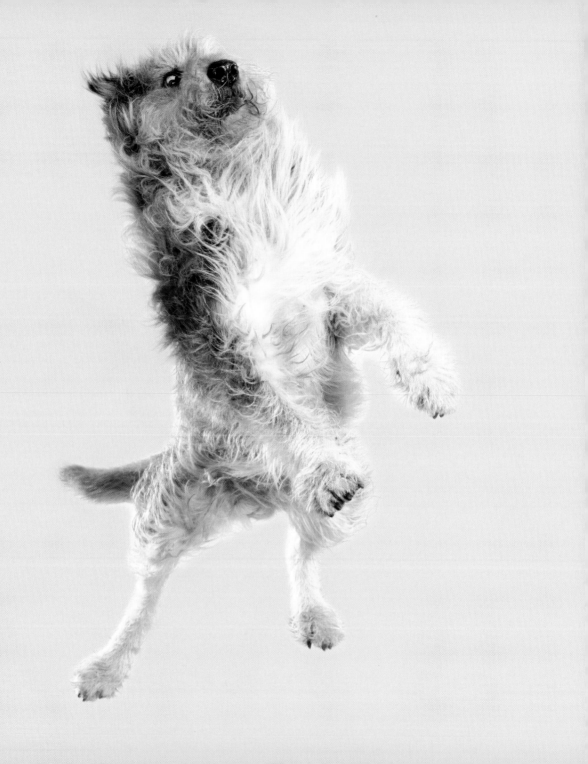

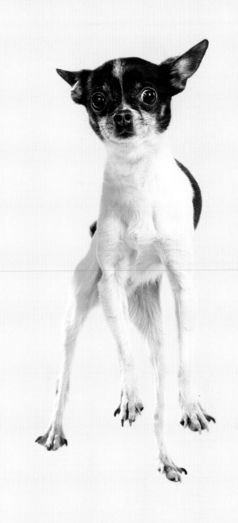

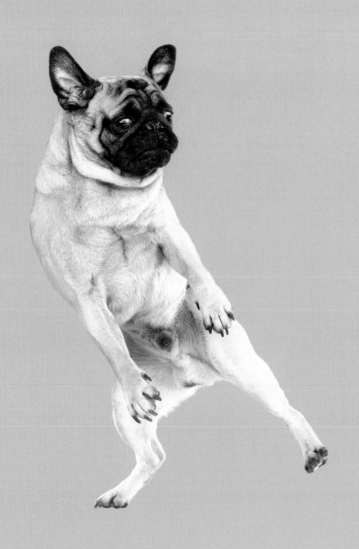

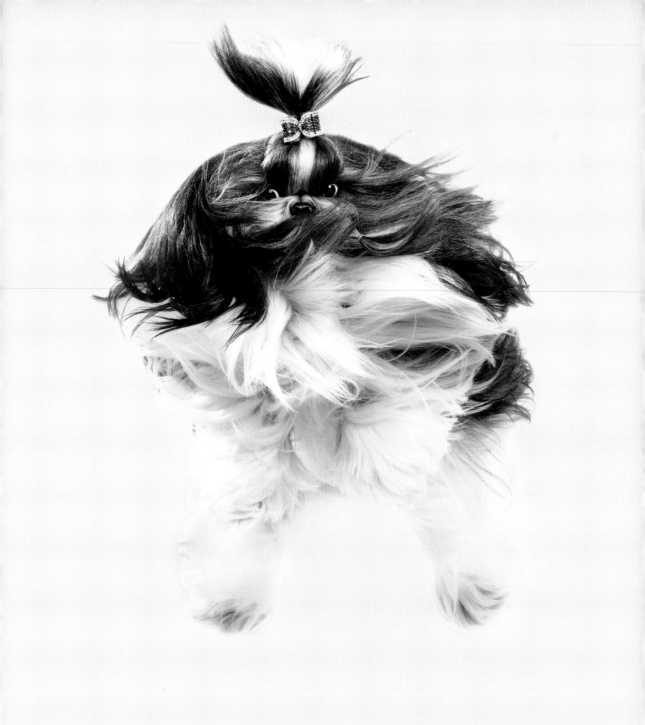

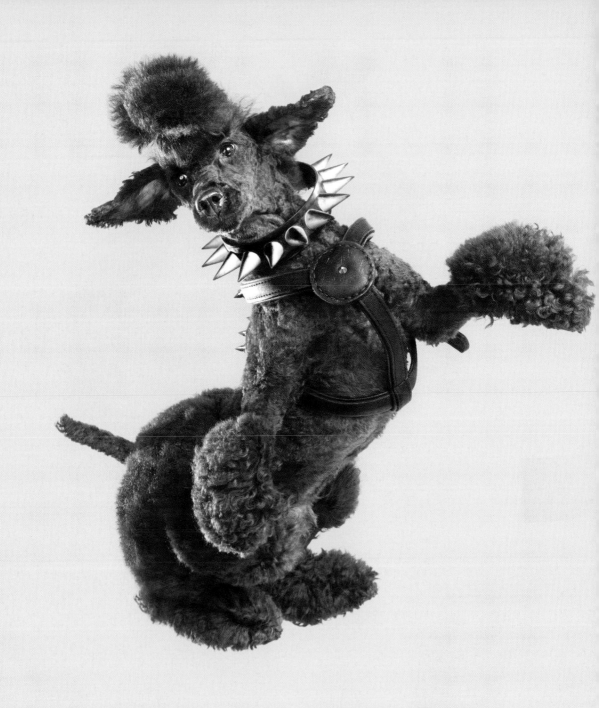

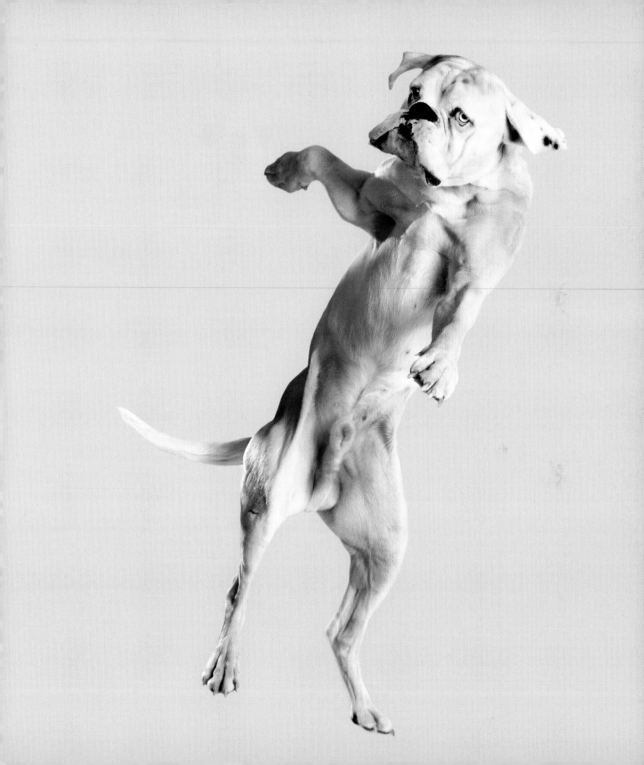

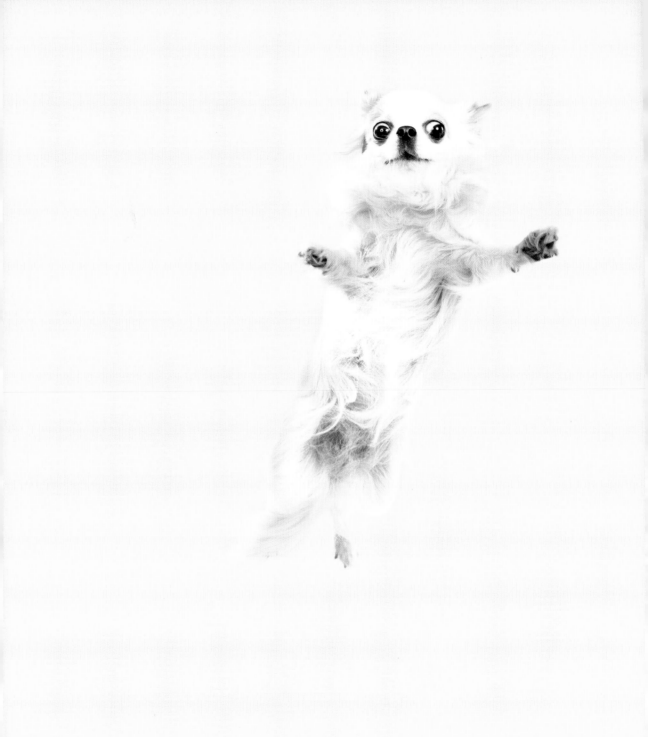

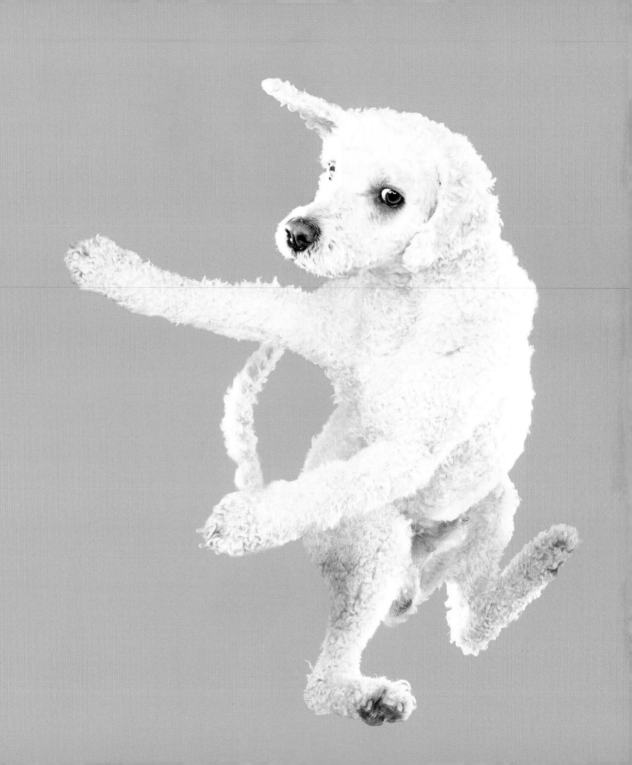

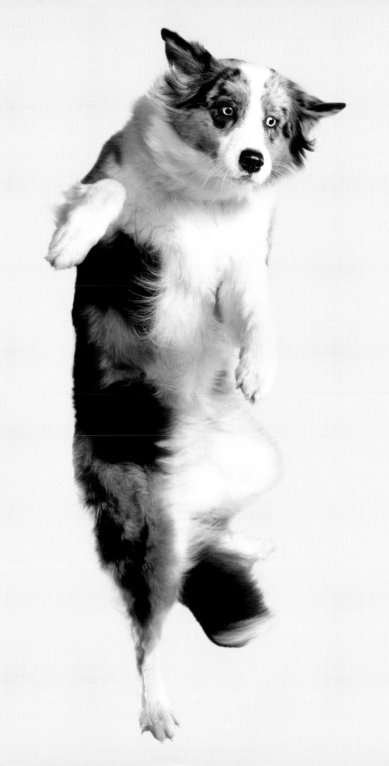

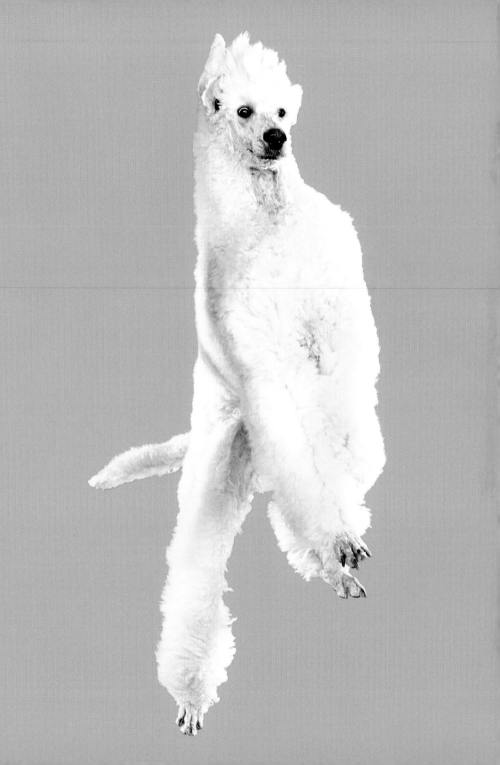

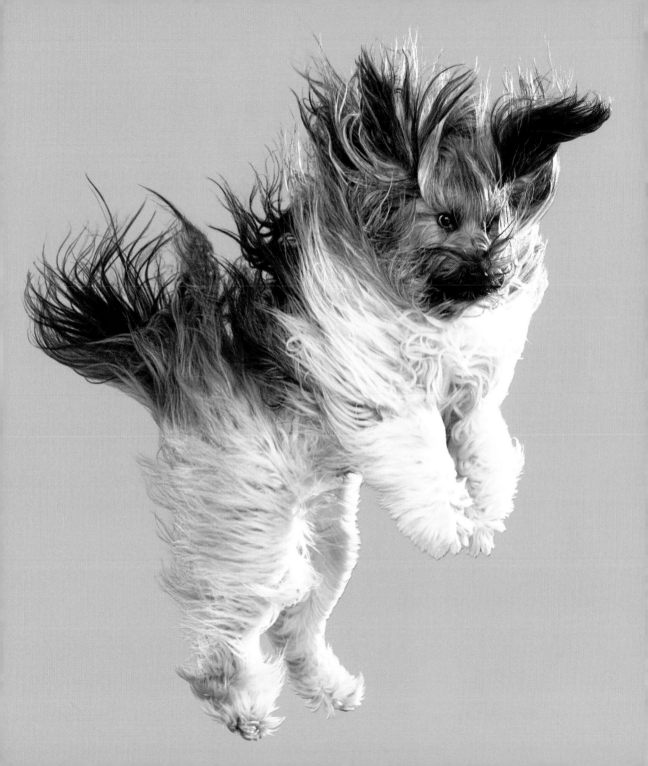

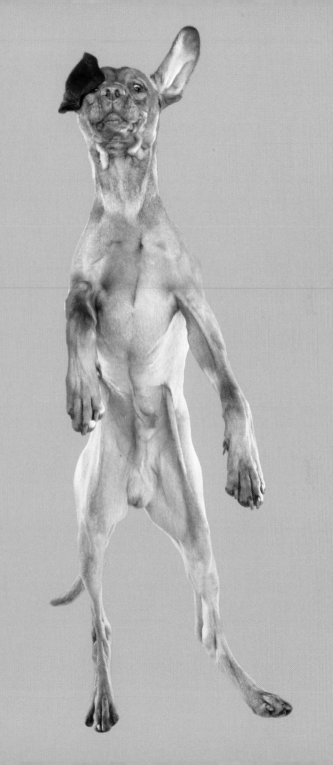

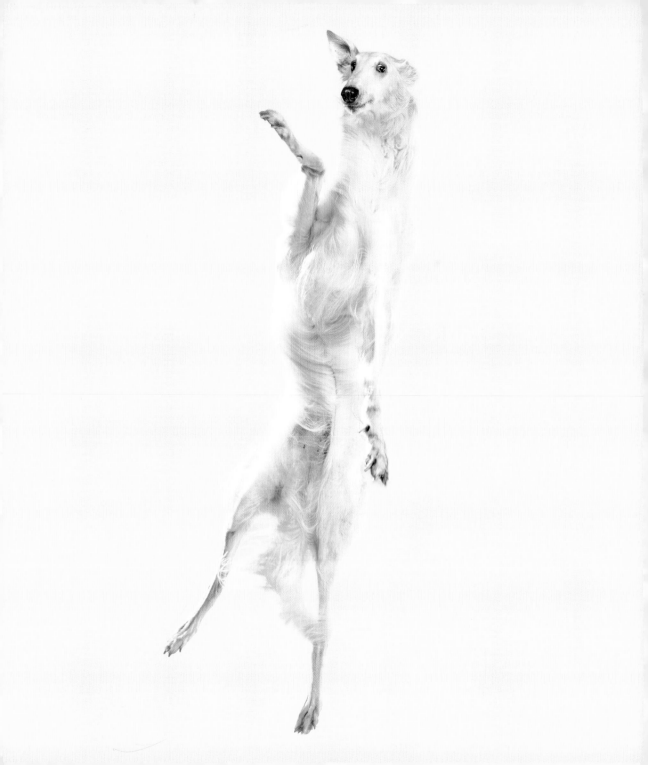

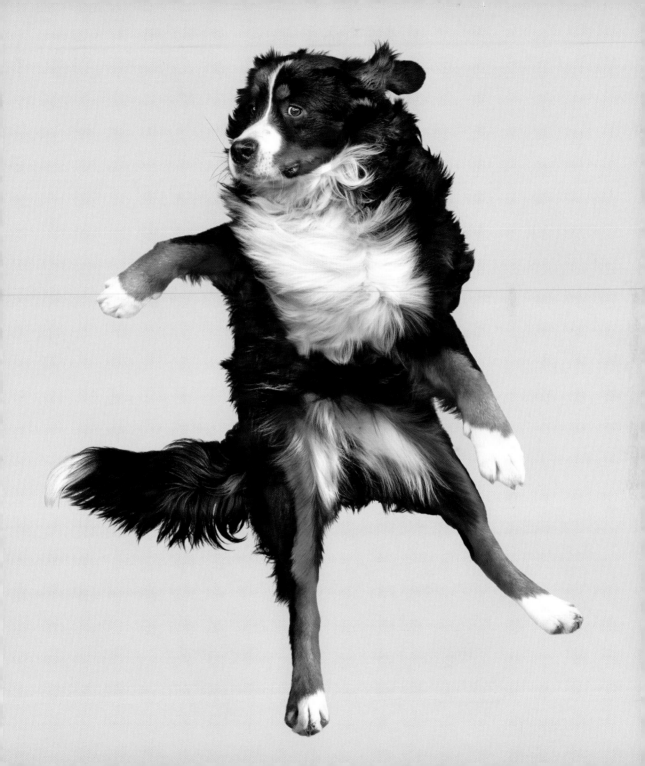

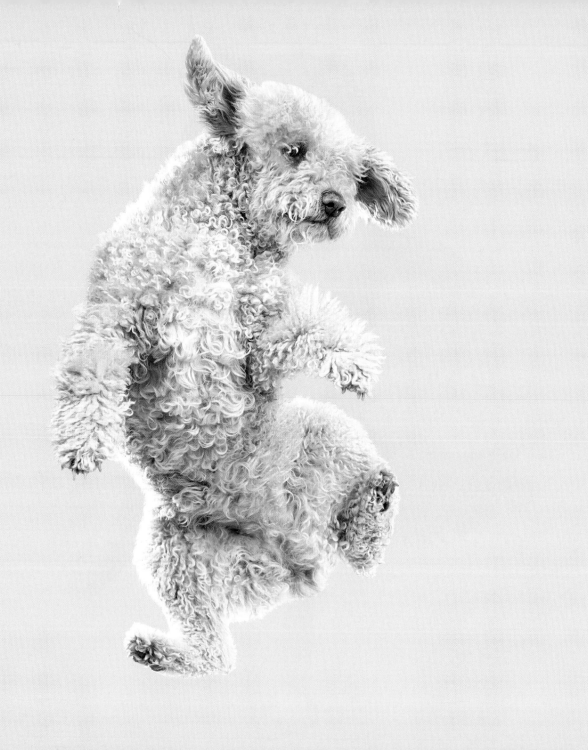

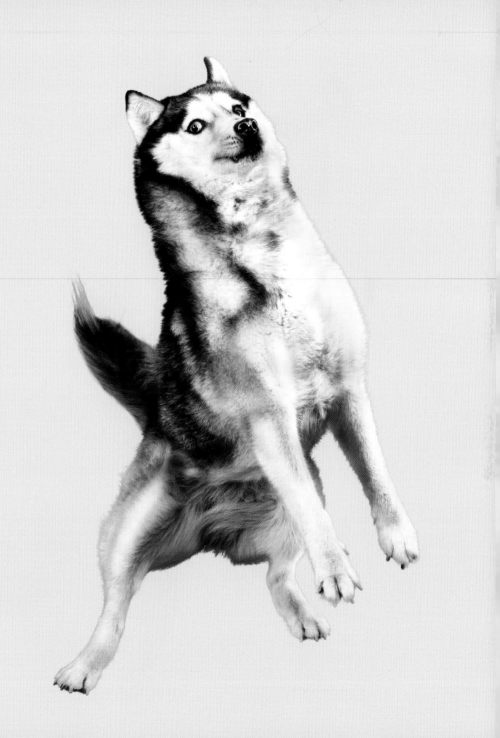

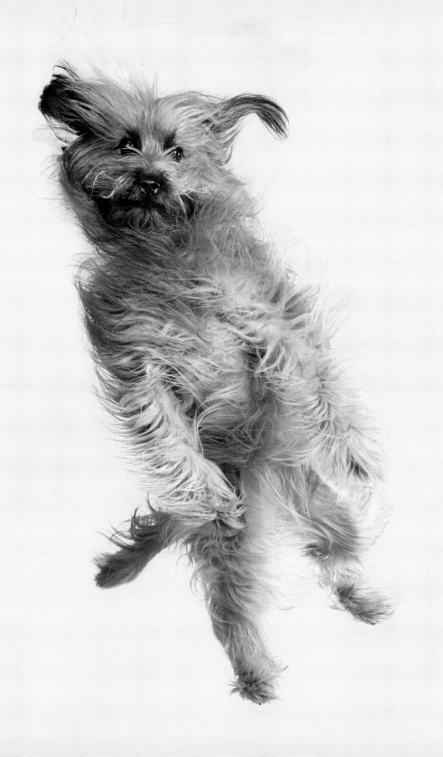

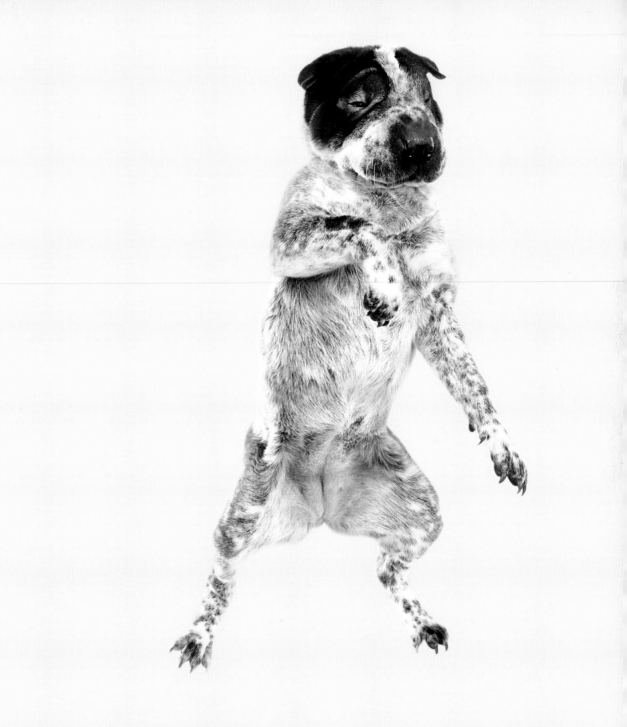

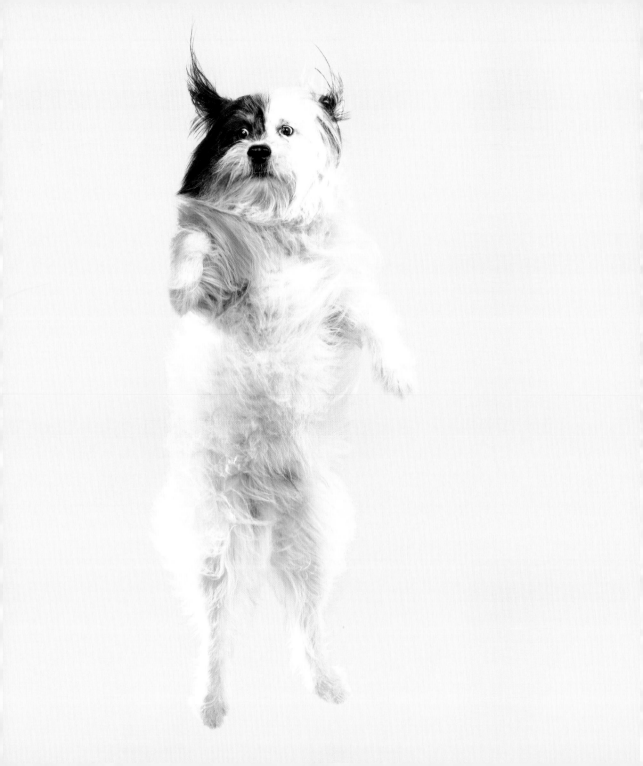

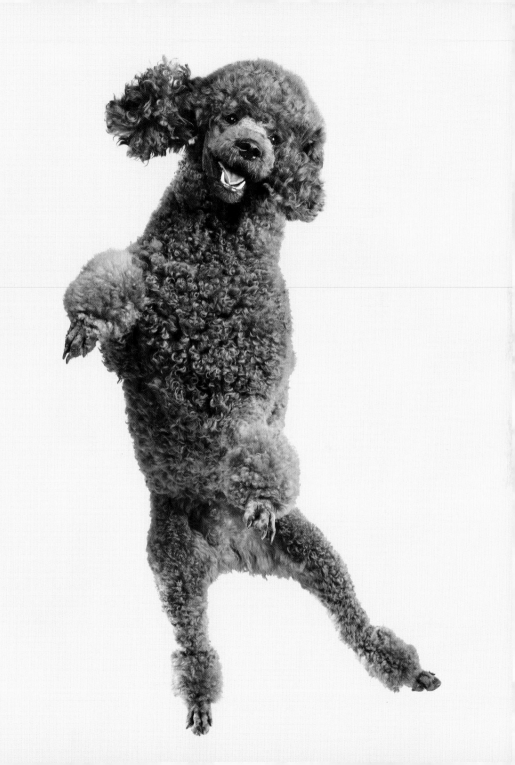

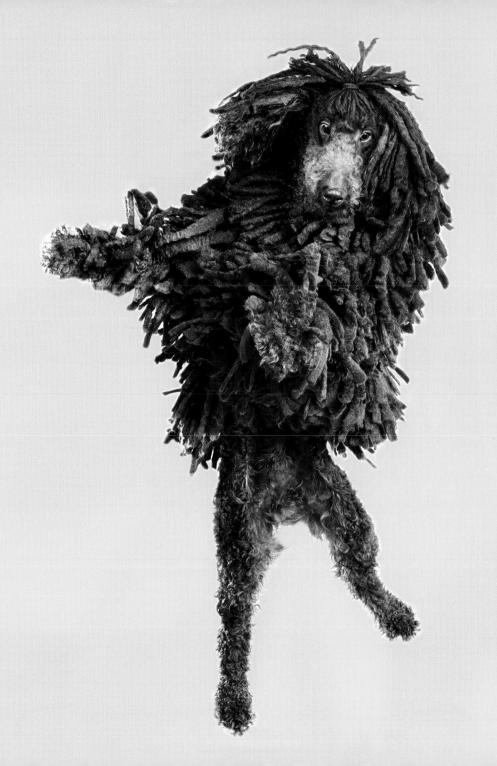

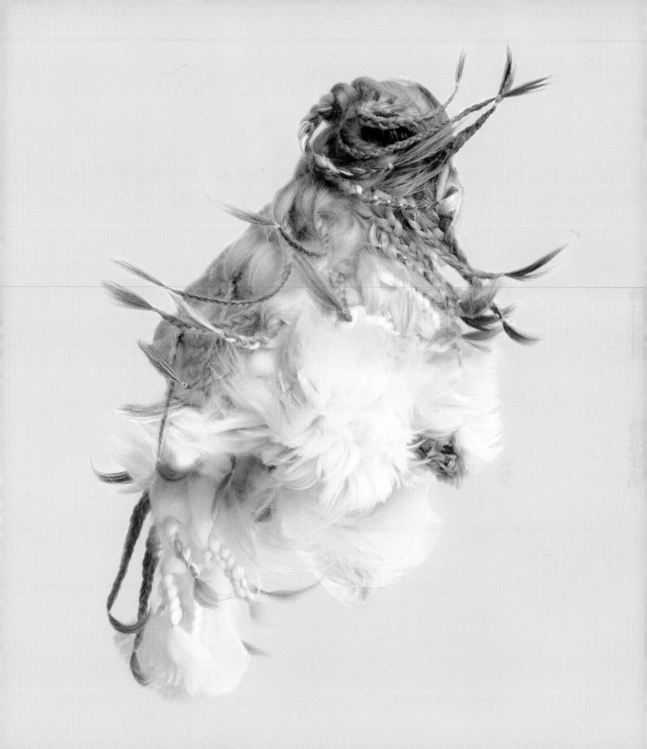

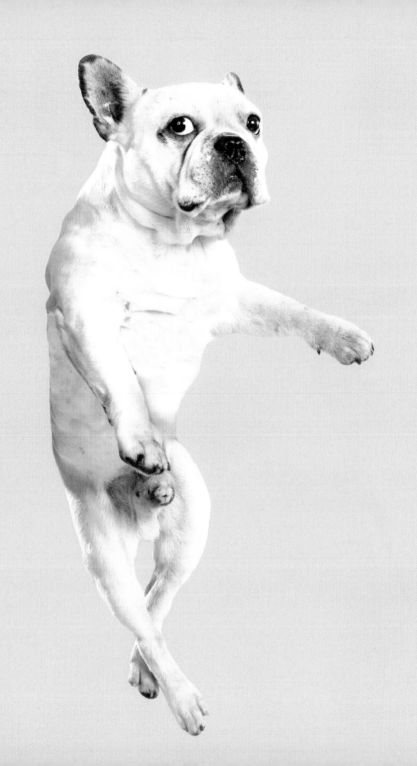

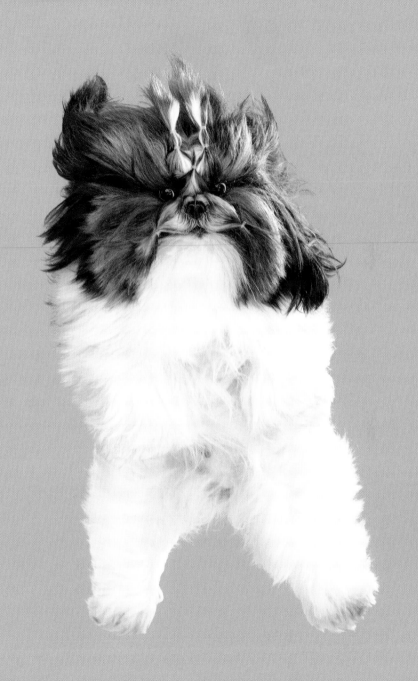

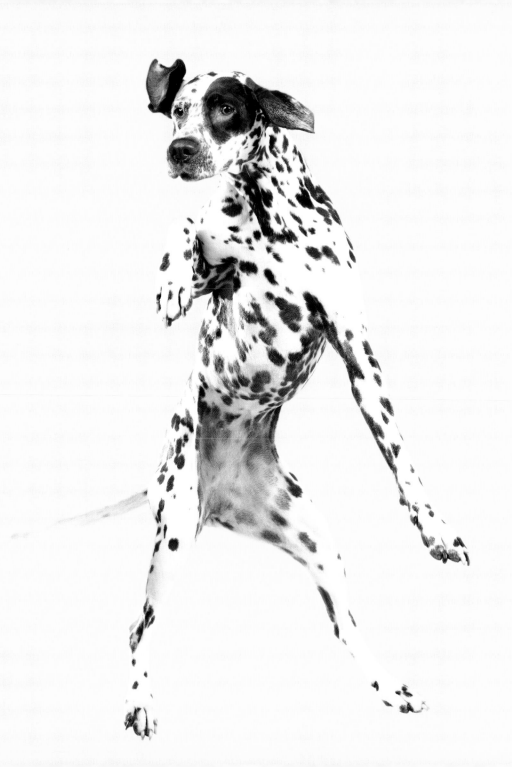

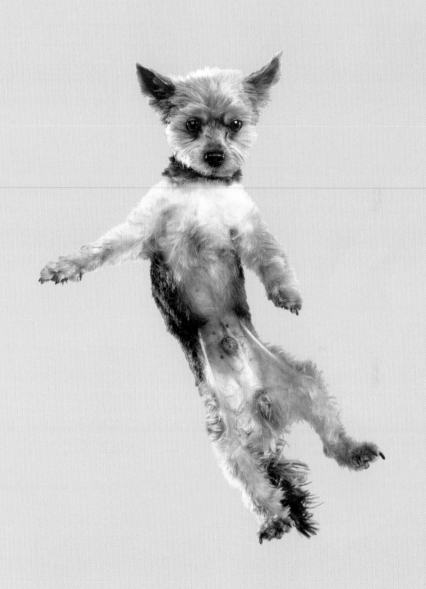

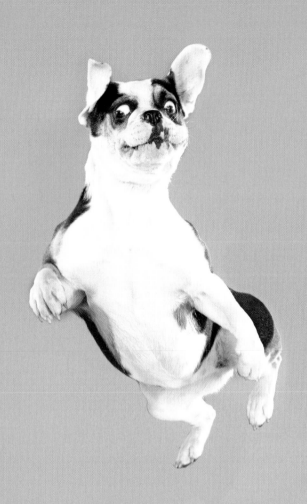

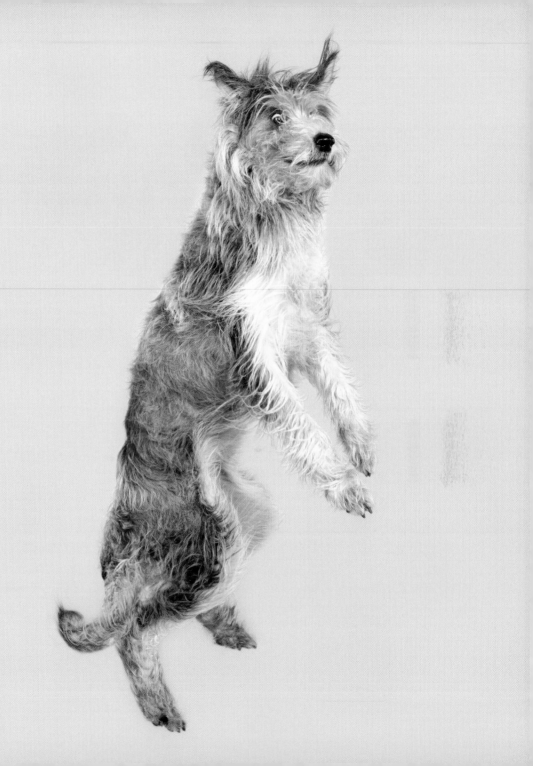

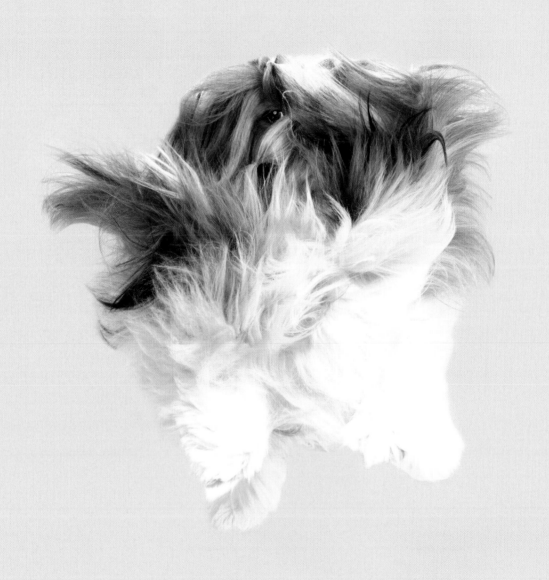

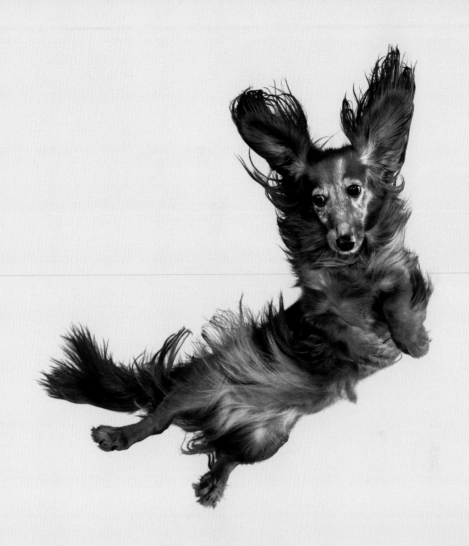

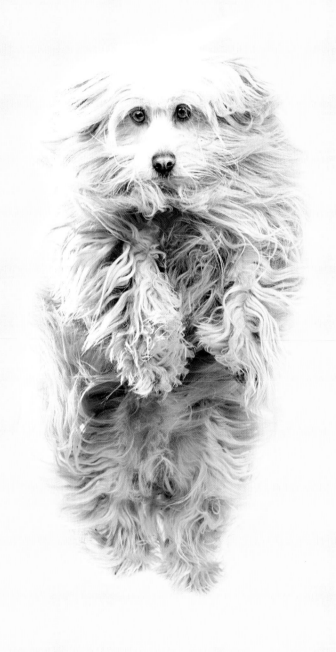

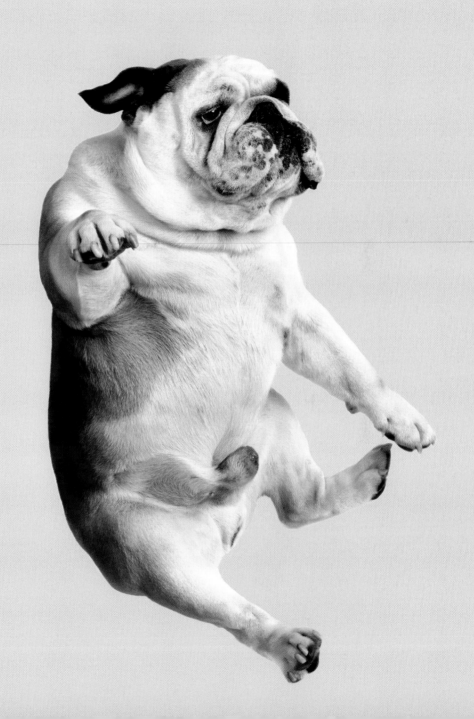

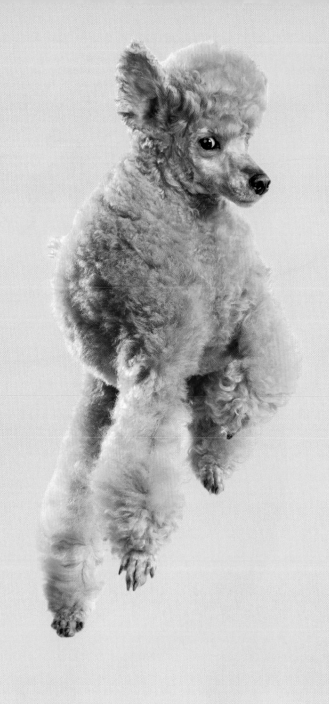

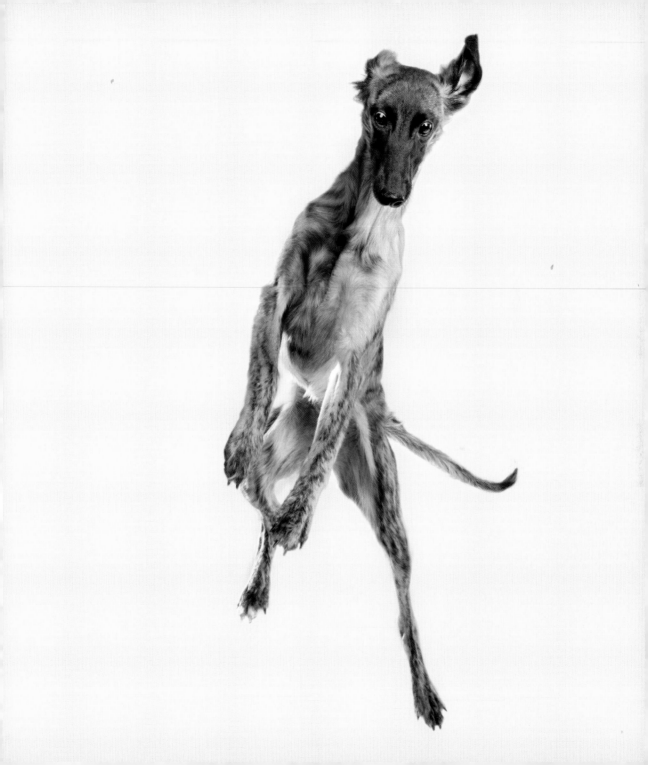

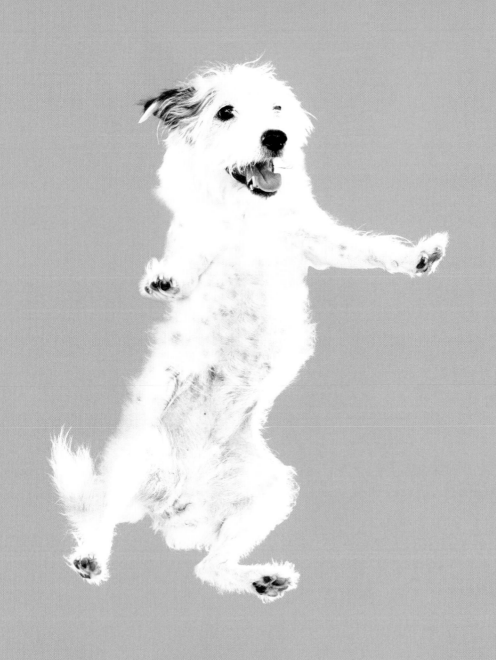

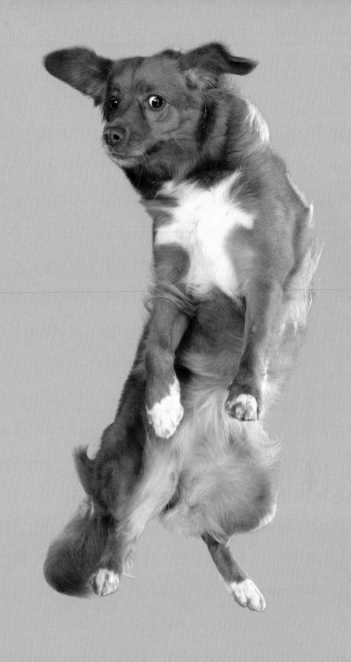

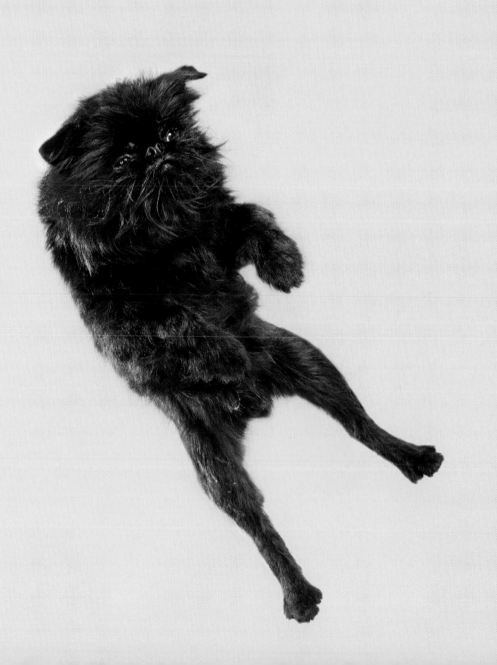

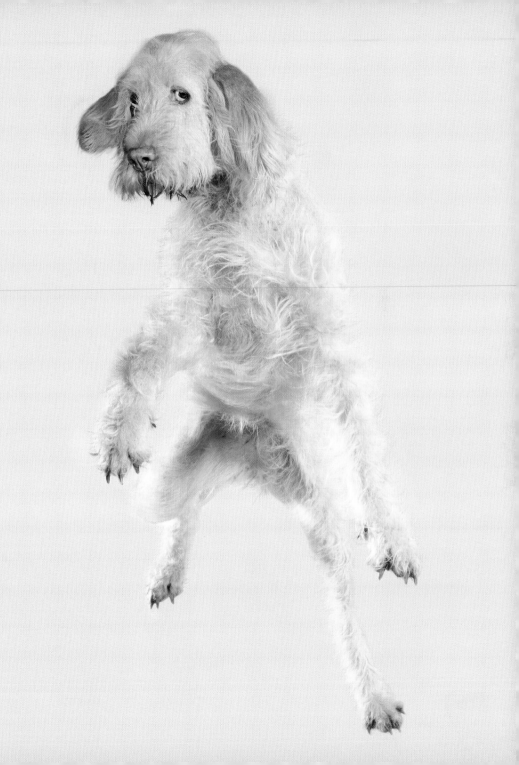

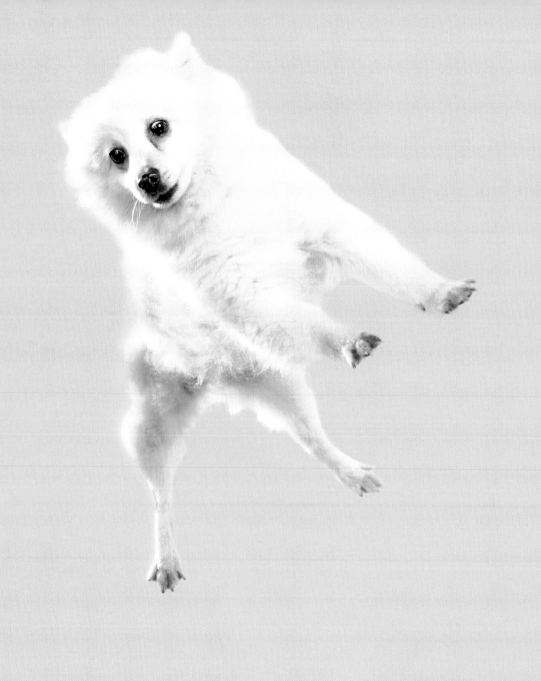

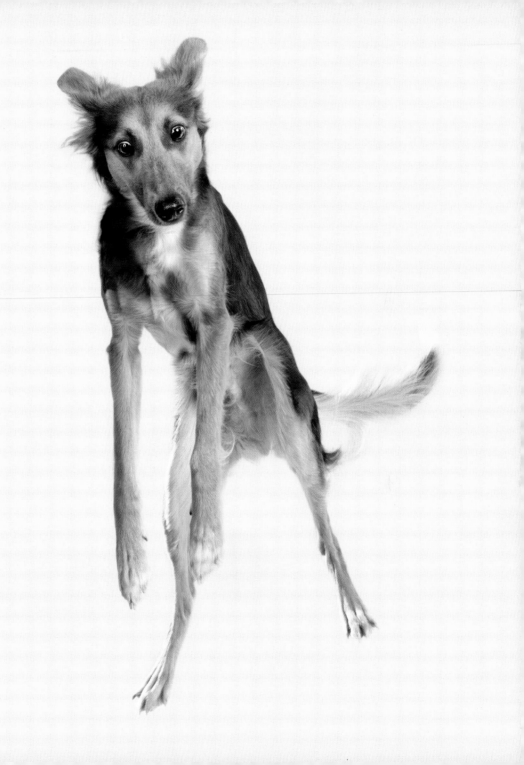

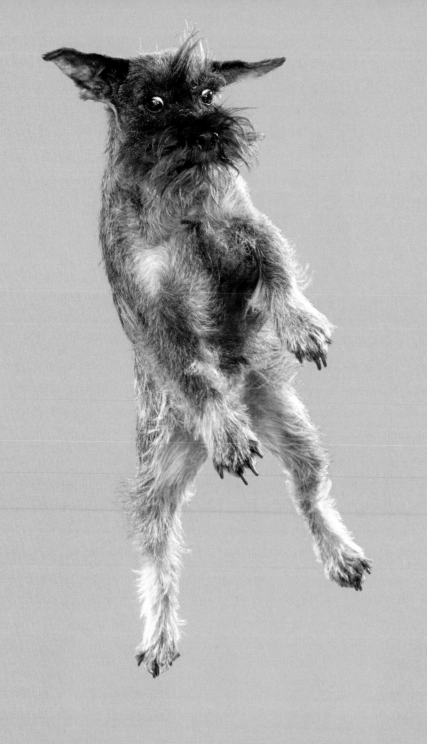

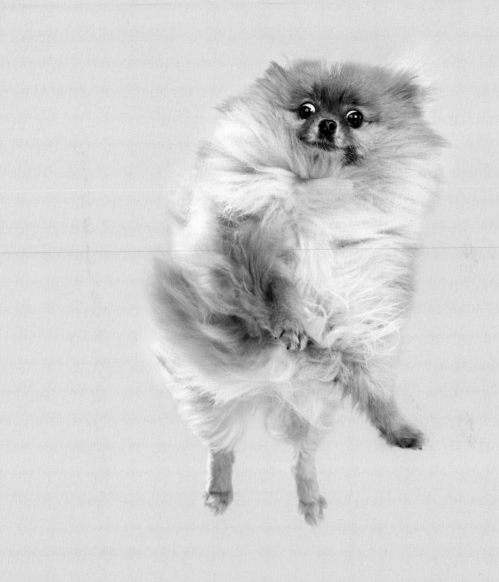

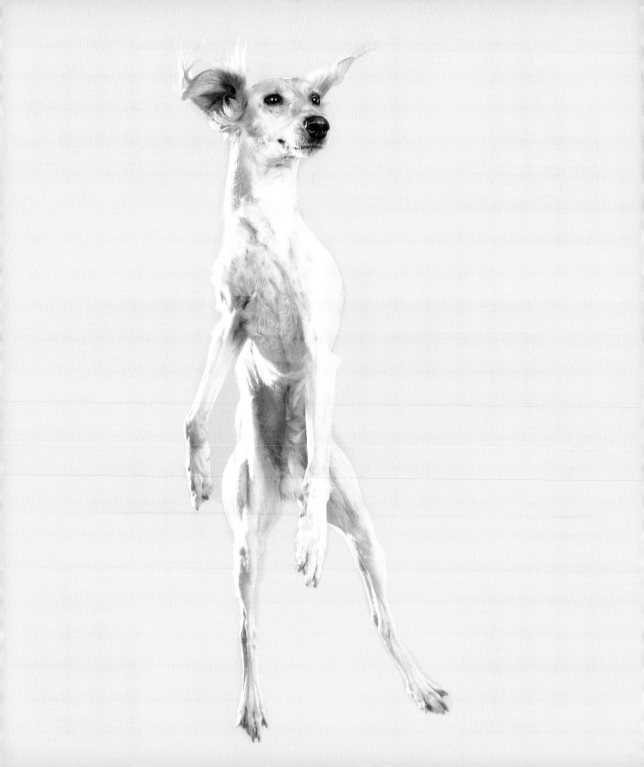

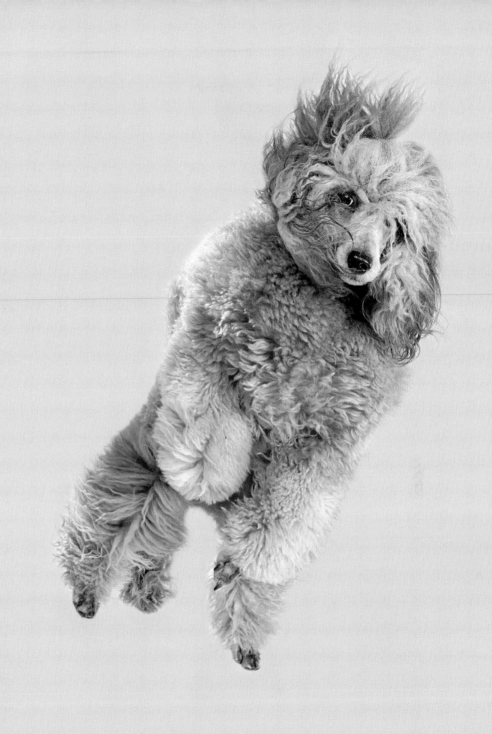

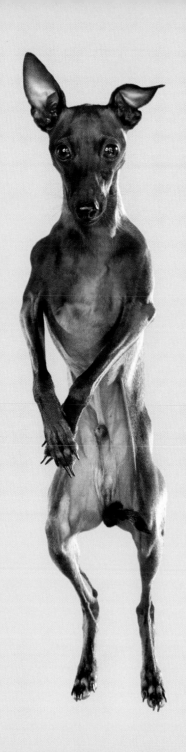

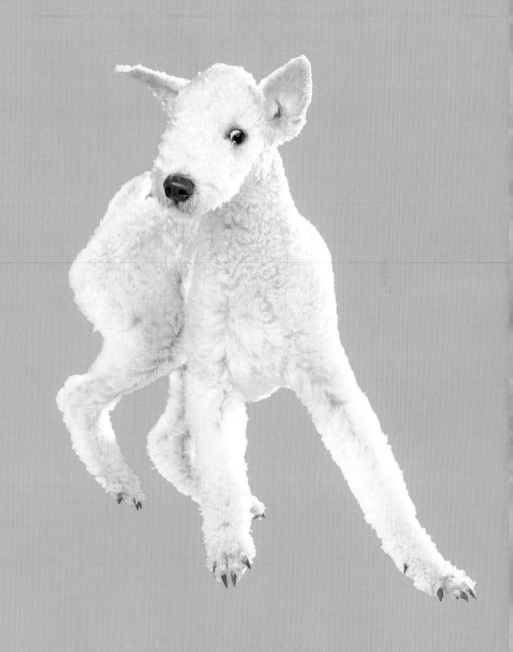

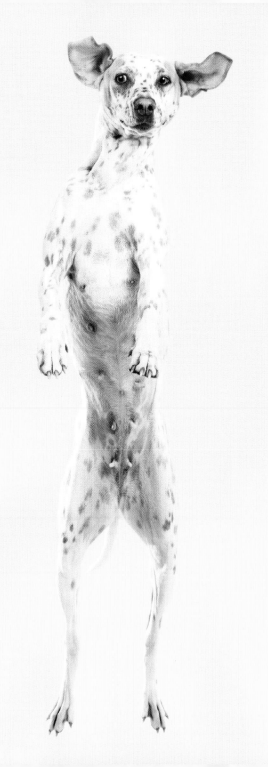

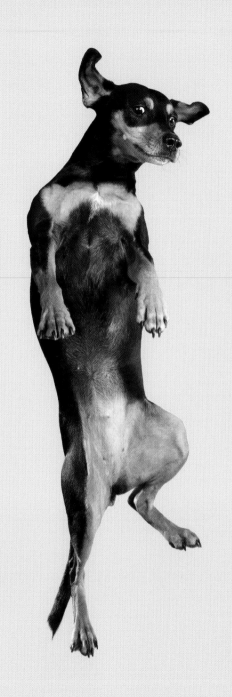

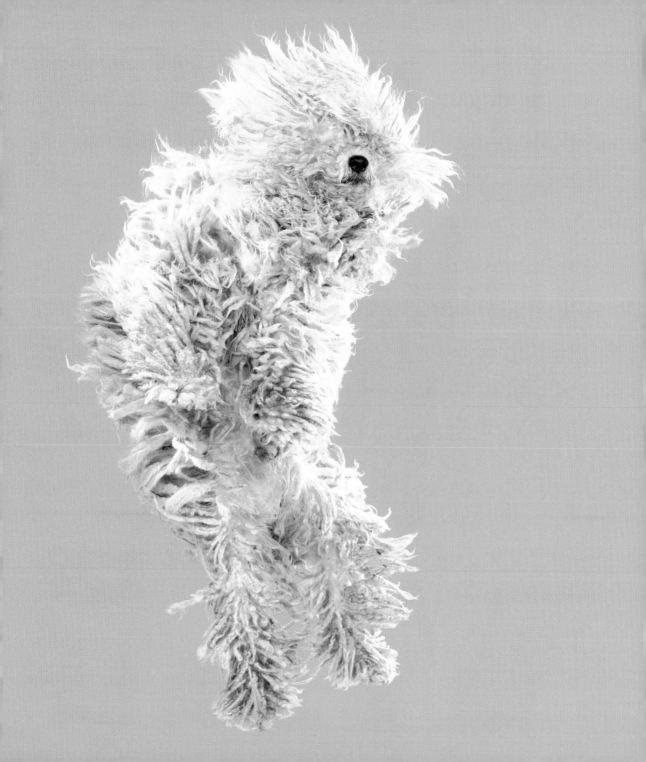

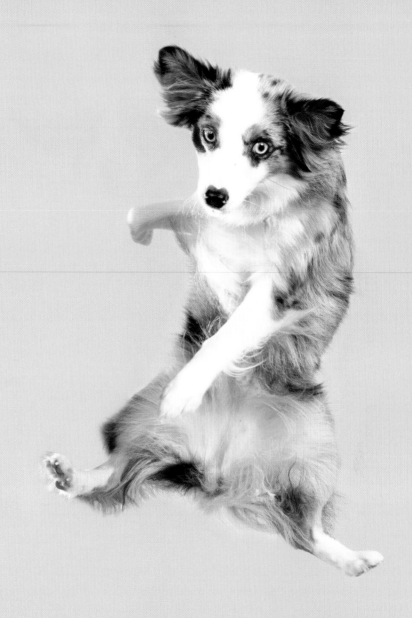

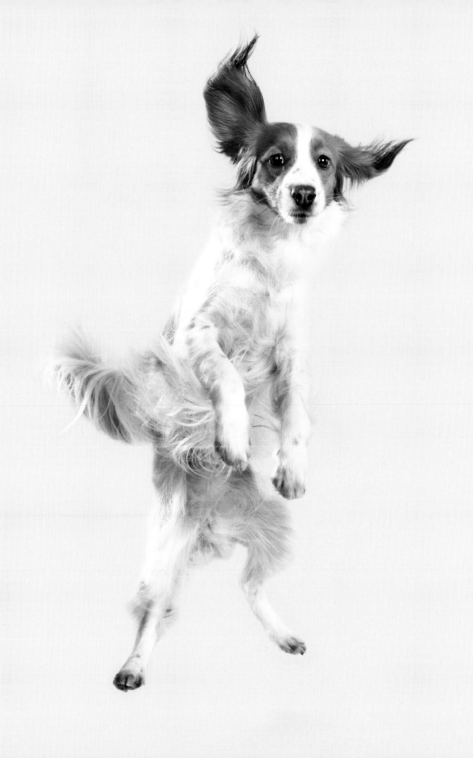

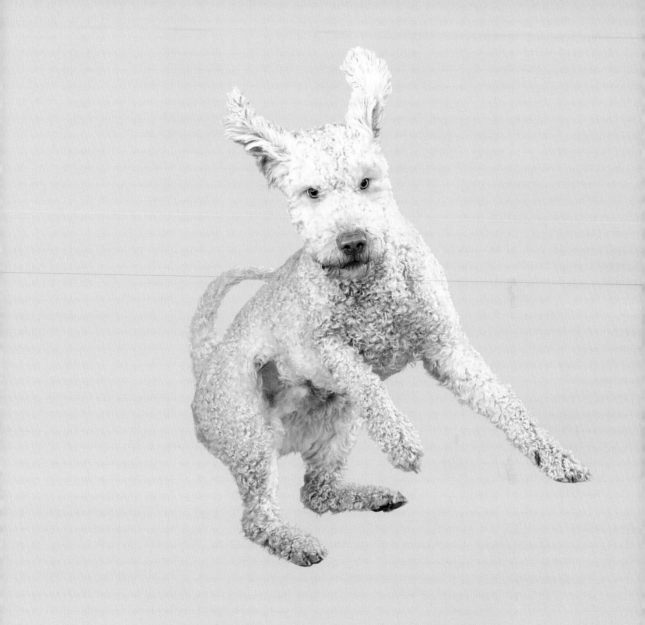

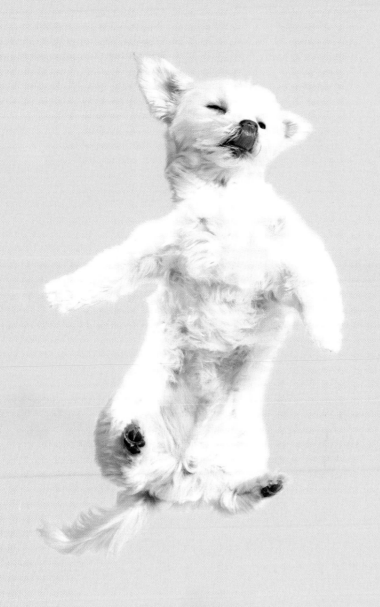

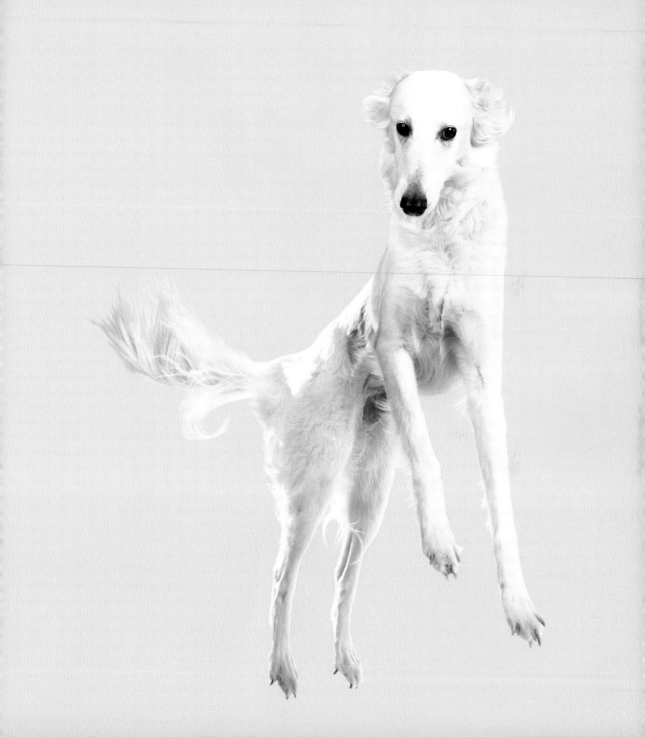

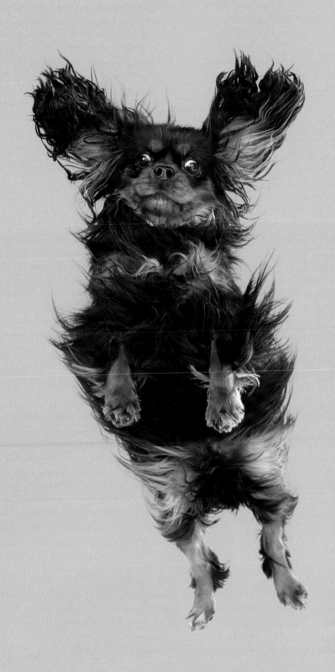

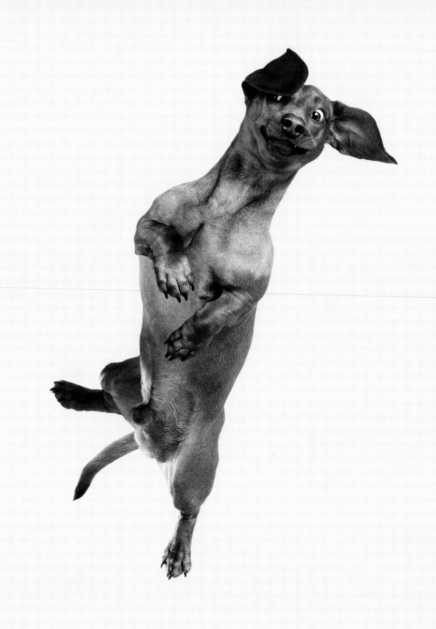

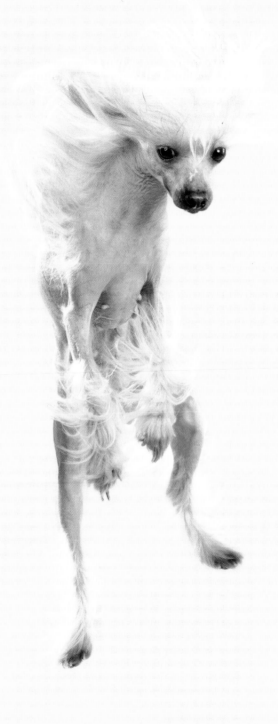

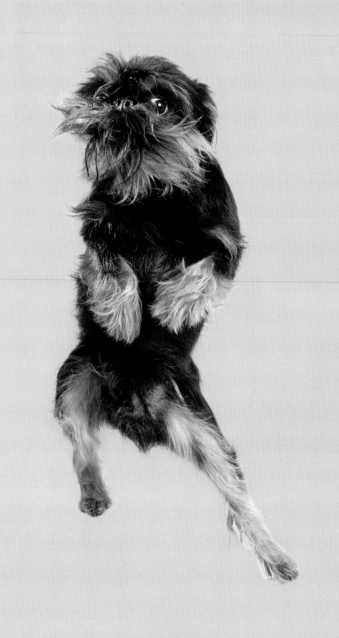

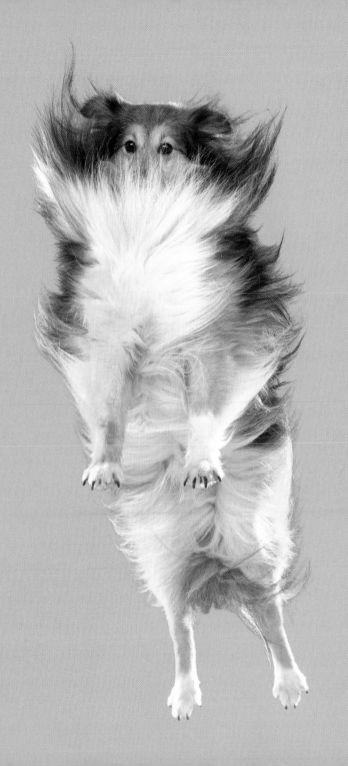

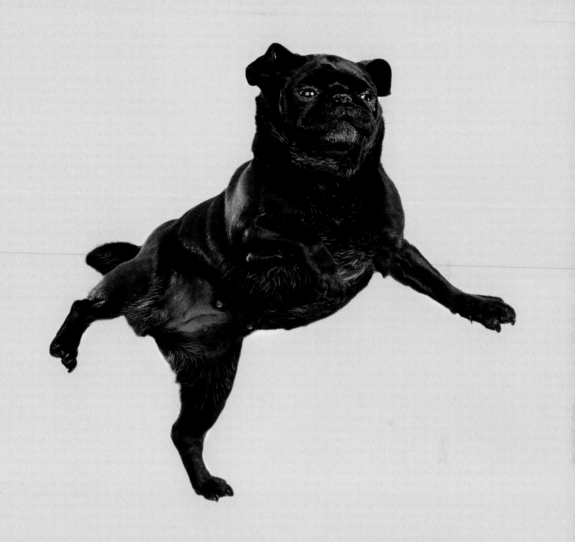

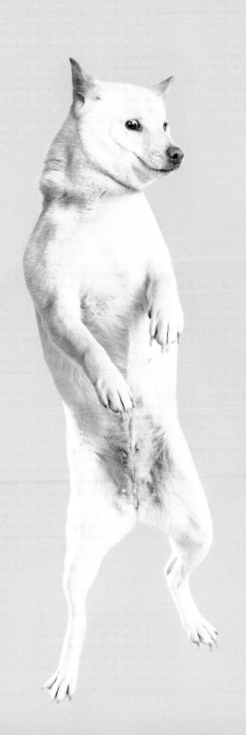

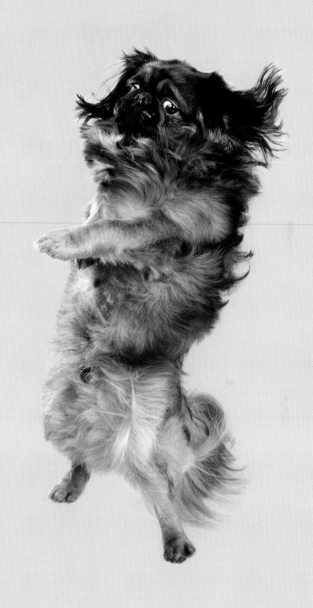

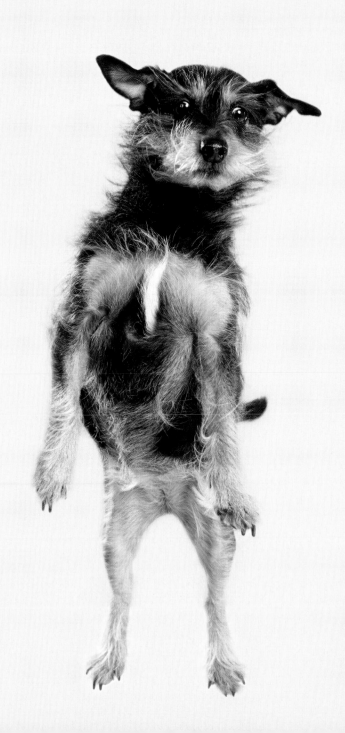

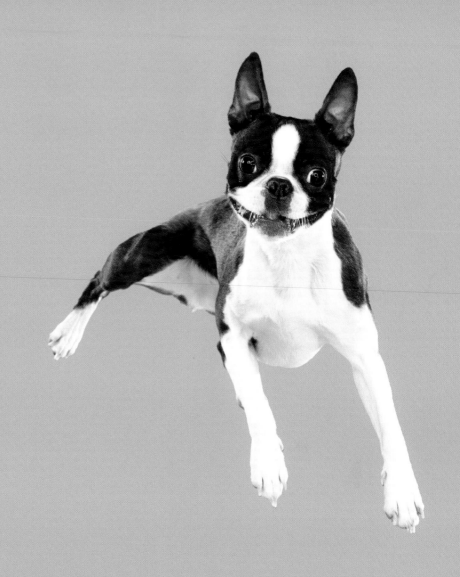

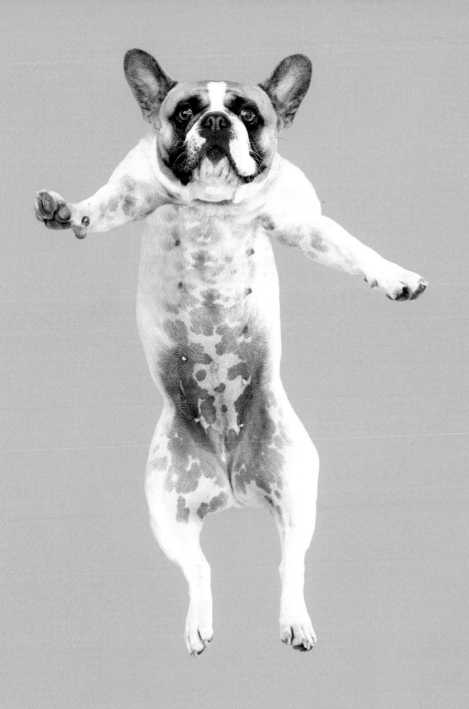

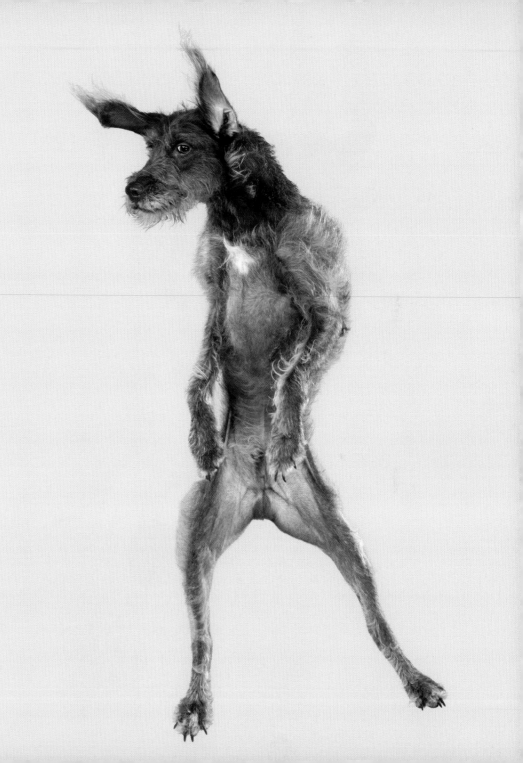

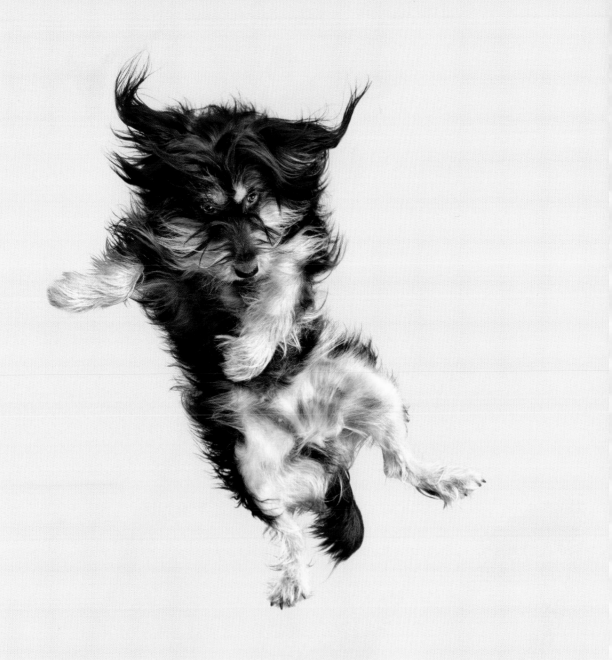

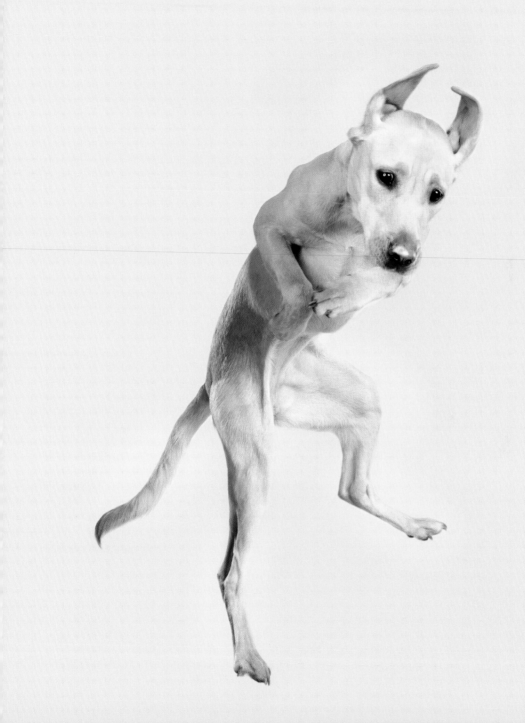

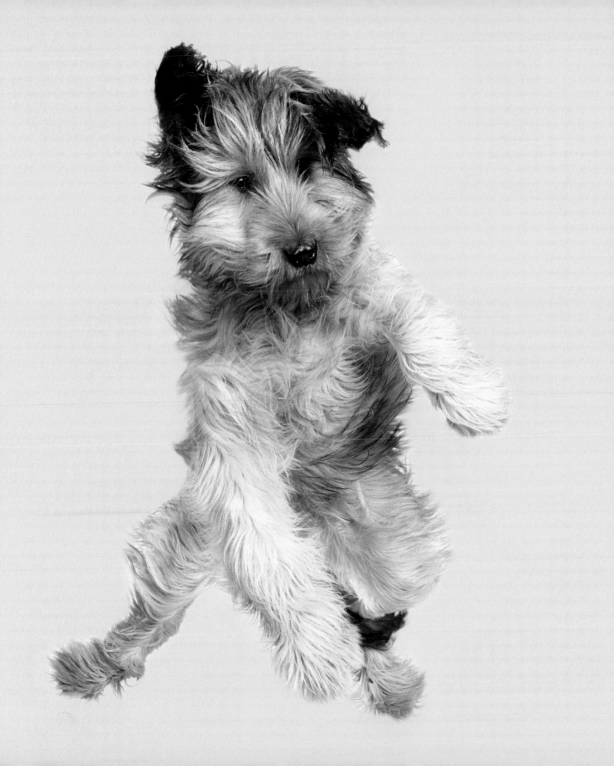

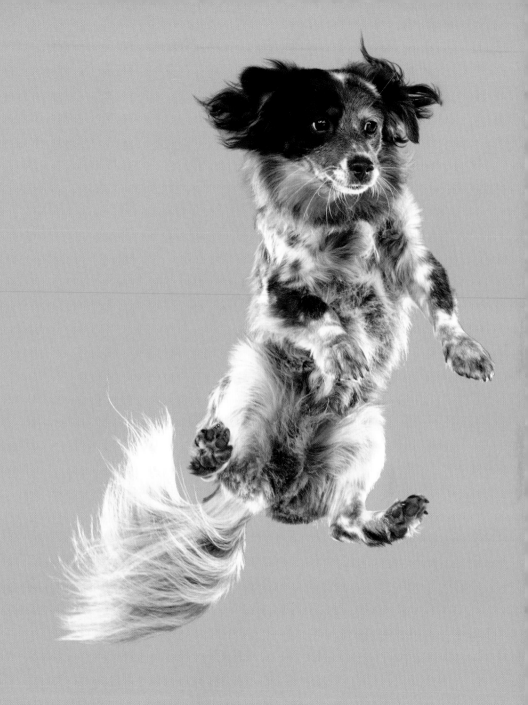

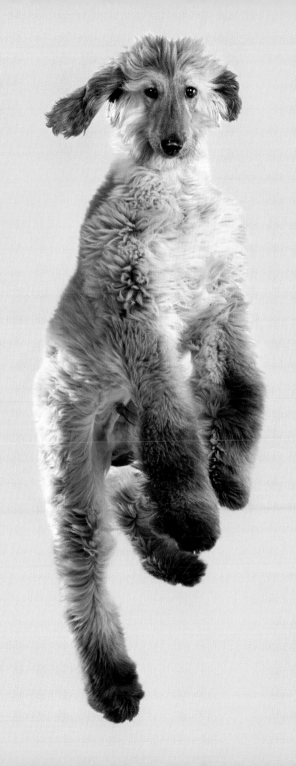

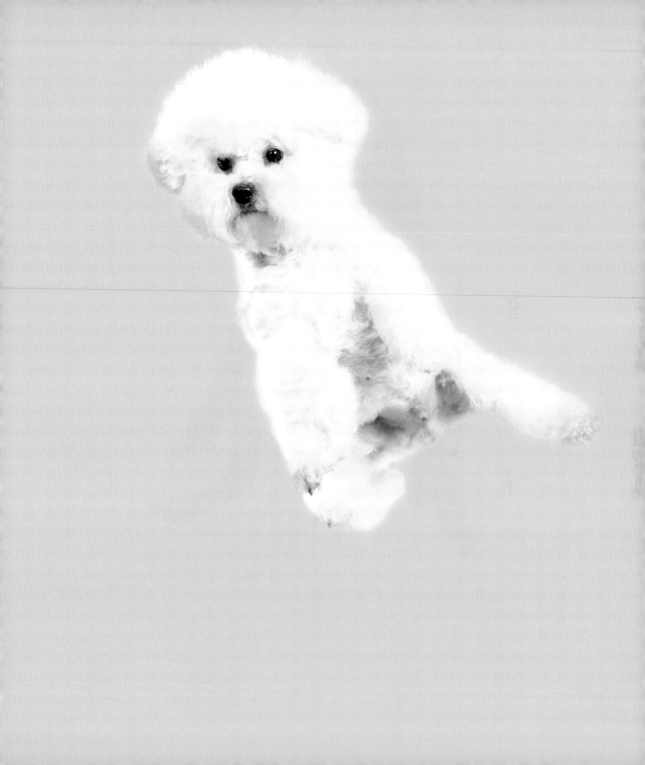

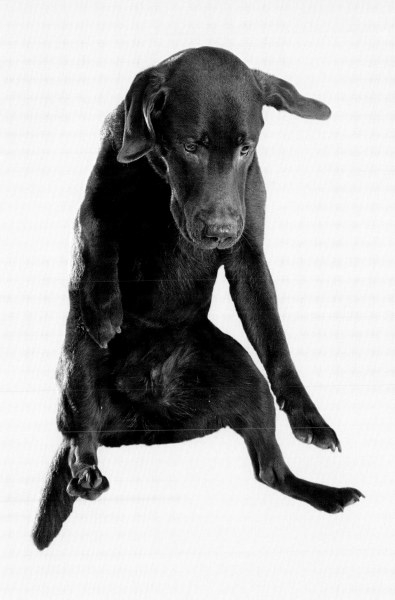

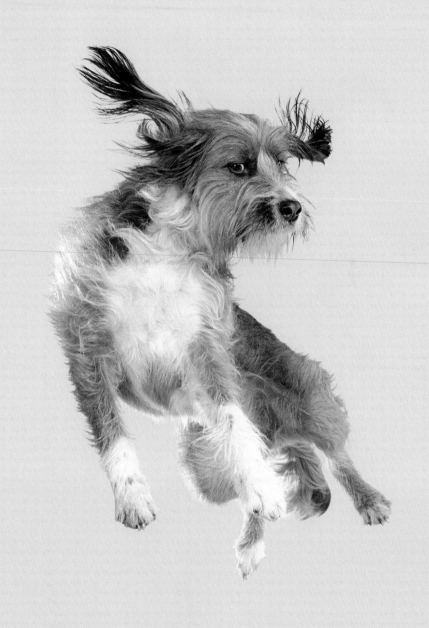

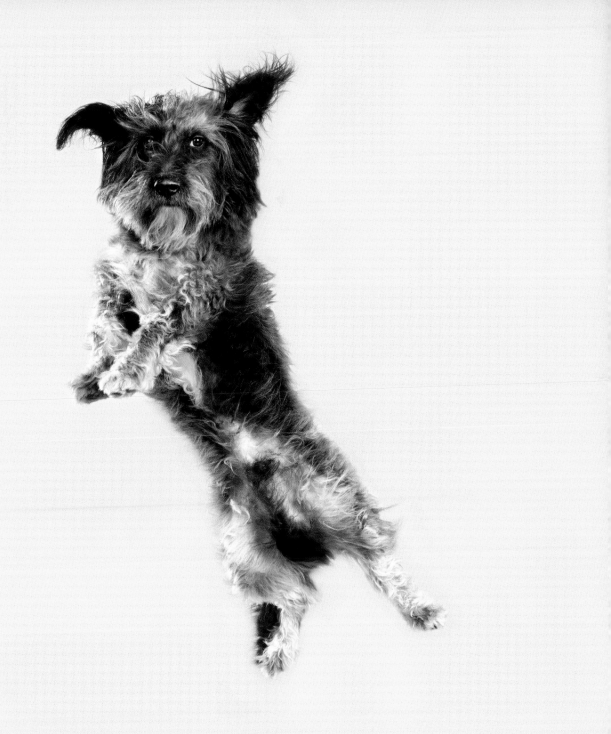

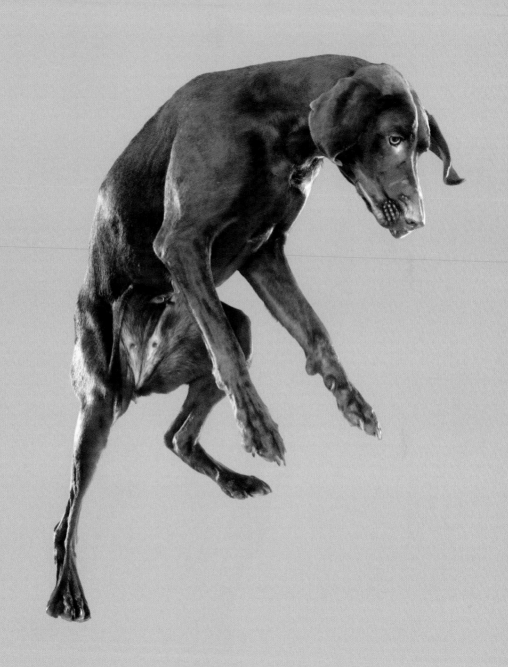

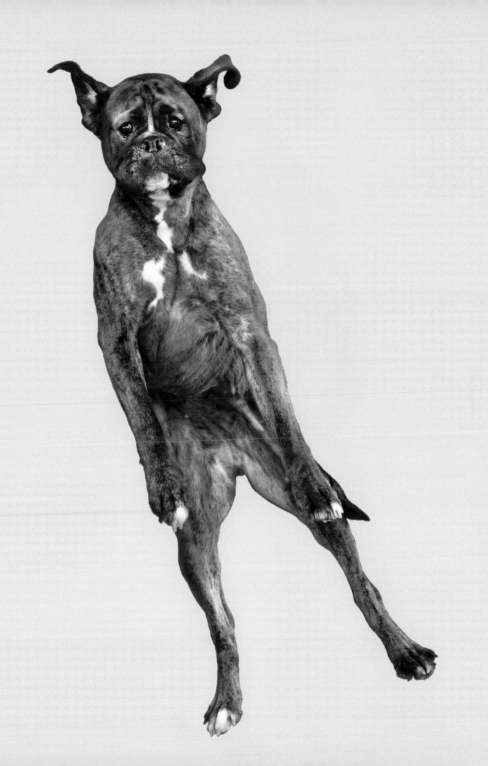

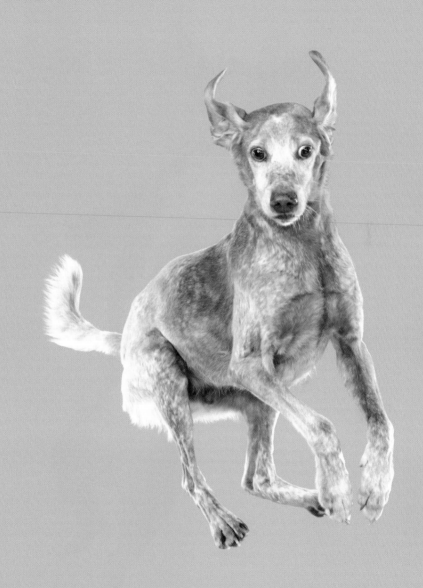

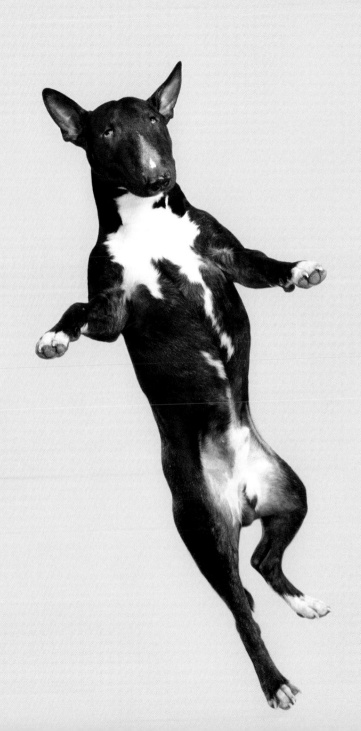

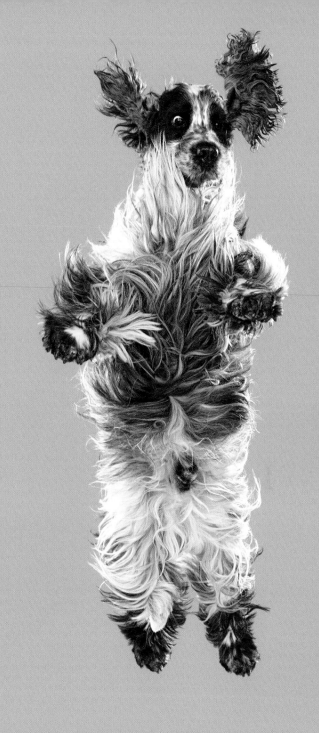

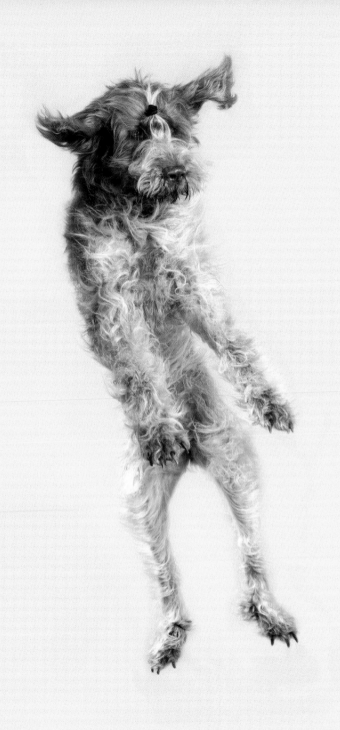

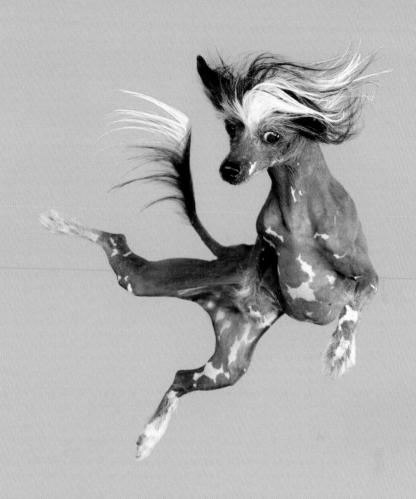

BEHIND THE SCENES

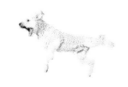

I went up into the air for the first time, photographically speaking, in 2006. At the time, I was interested in parachuting, and photographed a series of parachutists. From there, it seemed like a small step to go back down to earth and add pictures of my then dog, Lucca, to the series of parachutists. This experience inspired me to begin working with dogs, leading to my first project featuring them, "Ups & Downs," a small, simple studio series with only basic technical equipment.

In 2007, my Spanish Water Dog Flinn came into my life. As a puppy, he followed his hunting instincts and became particularly fond of Frisbees, which he jumped to fetch without caring how he would ever get back down. If I let him, he would go after anything, jump as high as he possibly could. He knew no boundaries. So he began to spend a half day with me in the studio chasing Frisbees as I tried to capture his jumps on film. Soon it became apparent that my technical approach wasn't viable, not for him nor any other dog.

I began experimenting with my methods. In order to achieve a satisfying depth of focus, the photographer needs to have the object, in this case, the dog, at an exact distance. So I had to find a way to have the dogs jump at the exact same spot. After trial and error, I found that the best approach involved the dogs jumping within a 20cm (7.8 inches) range. I had to prevent the Frisbee, which I used as bait, from covering their faces. And I had to ask myself if these "flying dogs"—with their wide open snouts and crazy looks—looked a bit too weird.

Outside, I could set the scene effectively for dogs chasing after Frisbees, using a flash and a simple background, but I found it impossible to plan appropriate illumination for the wide variety of breeds I invited for the project. And I didn't think I would be able to find a pug or a bulldog or a greyhound in Berlin with the necessary joy of hunting Frisbees.

A few years later I had a chance to work with the flying dogs again, when a commission came up for a veterinary-product advertising campaign. This time, I had much better technical equipment and a more sophisticated set.

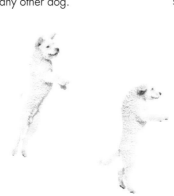

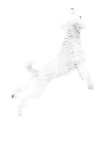

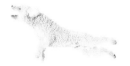

I needed to find an effective solution to make the dogs fly. I had a number of criteria. First, my method had to be safe for a healthy dog, one that required minimal—if any—strain on the dog, and work on the first try, in order to capture the surprise effect. Second, I needed to tailor the approach for different breeds and constitutions. Finally, it had to be doable for all dogs without previous training, requiring a low height while still *seeming* dynamic. I finally came up with the method that I would use throughout the shootings: rather than have the dogs jump after a ball or a Frisbee, I would have their owners or an assistant hold them at a certain height, depending on the dogs' size, and release them onto a well-padded mattress, allowing me to closely monitor the area where I would shoot.

The funny expressions on the dogs' faces come from surprise. In the studio, the dogs were confronted with a lot of strange odors, a wind machine, and flashlights. The first attempt usually created best looks; on subsequent tries, most dogs learned to look toward the ground. After three jumps, the dogs knew the routine and no longer appeared surprised.

The huge success in the media around the world finally led to the book project. But there were also false allegations about how the dogs were treated on set. Some people didn't understand that a wind machine and post-production created the real illusion of flying.

As usual, only my own dogs Flinn and Turre know the greatest pleasure of this project: a wonderful weekend spent in the company of many lovely dogs and their owners, with a lot of encouraging words and treats, balls or Frisbees, and some exquisitely beautiful female dogs.

For more information and behind the scenes footage, visit http://www.flyingdogs.info/.

ACKNOWLEDGMENTS

First and foremost: thank you to the roughly two hundred dog owners who accepted my invitation and came to the studio with their dogs, in some cases traveling far and wide to get to Berlin. Berlin is famed for being the capital of dogs, but nevertheless, not even there can you find all the breeds. My special thanks to Angelika Silber who brought her very attractive dogs to three of the sessions and sacrificed valuable time for very special hairstyles for them. Also many thanks to Jana Posna, whose poodles are real stars.

Thanks also to the vet Jana Czernutzky from Berlin who helped me find extraordinary breeds and consulted me on many technical matters, such as the desired thickness for the mat where the dogs jumped on. She was also present during one shoot.

Thank you also to my husband, Rene, my friends Eva Göllner, Peggy Reimer, and her friend Andreas, without whose practical help on set I would never have managed.

Thanks to my loyal assistant, Andreas Musculus, who labored by my side through the four dog photo shoots, and he doesn't even like dog hair! I will be eternally grateful for his technical insight and calm demeanor, which helped us through difficult moments, for example: when a flash generator didn't work, the dogs were running out of treats, and he calmly had the situation under control in no time at all.

Another great thanks to the team of Delight Rental Service (delight-rent.com) in Berlin for providing exceptionally good light equipment under difficult circumstances.

To Delight Studios Berlin (delight-studios.com) and Konsum Studio (konsum-studio.de), who trusted me with their studios despite me announcing that over a hundred dogs were visiting!

Thanks to my friends Sonja Hilzinger (www.sonjahilzinger.de) for project consulting and editing and Eva Göllner (www.bellalingua.de) for translating into English.

Thanks to my friend Volker Lutz, who spent many hours of pixel acrobatics on the computer, making sure that the dogs were really flying—every single fine hair included.

Thanks to the cameraman Andreas Haas, for shooting the making-of on set.

Very special thanks to my teacher and longtime friend Peter Lütkemeyer from Folkwangschule Essen who has always been by my side with advice concerning photography and other matters of life.

And finally, without Myrsini Stephanides of the Carol Mann Agency, the project would never have materialized into a book, because she found my flying dog series on the Internet and helped me convince Michelle Howry of Simon & Schuster to make this endeavor a reality. Thank you to Kaitlin Olson, Jessie Chasan-Taber, and Lara Blackman for taking such excellent care of all my flying dogs through the production process and getting them to the printer.